The **Kodak** Most Basic Book of Digital Photography

The **Kodak** Most Basic Book of Digital Photography

Jeff Wignall

Kodak Books

Published by Lark Books

A Division of Sterling Publishing Co., Inc.

New York

Editor: Haley Pritchard
Book Design and Layout: Tom Metcalf
Cover Designer: Thom Gaines
Associate Art Director: Shannon Yokeley
Editorial Assistance: Delores Gosnell
Illustrator: Orrin Lundgren

Library of Congress Cataloging-in-Publication Data

Wignall, Jeff.
 The Kodak most basic book of digital photography / Jeff Wignall.— 1st ed.
 p. cm.
 Includes bibliographical references and index.
 ISBN 1-57990-762-8 (pbk. : alk. paper)
 1. Photography—Digital techniques. I. Eastman Kodak Company. II. Title:
Basic book of digital photography. III. Title.
TR267.W543 2006
775—dc22

 2005018013

10 9 8 7 6 5 4 3 2 1

First Edition

Published by Lark Books, A Division of
Sterling Publishing Co., Inc.
387 Park Avenue South, New York, N.Y. 10016

Cover Photos: © Dan Heller: Woman on the dock, © Robert Ganz: Two boys; Raccoon, © Jeff Wignall: Yellow flower; Southwestern landscape
Back cover photos: © Jeff Wignall: Flowers; Scenic vista, ©Kevin Kopp: Little boy, Illustrations © Lark Books

Distributed in Canada by Sterling Publishing,
c/o Canadian Manda Group, 165 Dufferin Street
Toronto, Ontario, Canada M6K 3H6

Distributed in the United Kingdom by GMC Distribution Services,
Castle Place, 166 High Street, Lewes, East Sussex, England BN7 1XU

Distributed in Australia by Capricorn Link (Australia) Pty Ltd.,
P.O. Box 704, Windsor, NSW 2756 Australia

If you have questions or comments about this book, please contact:
Lark Books
67 Broadway
Asheville, NC 28801
(828) 253-0467

Manufactured in China

ISBN 13: 978-1-57990-762-4
ISBN 10: 1-57990-762-8

For information about custom editions, special sales, premium and corporate purchases, please contact Sterling Special Sales Department
at 800-805-5489 or specialsales@sterlingpub.com.

contents

introduction

With a Digital Camera You Can...

Say Goodbye Film!

If there is one obvious (not to mention delightful) advantage to digital photography, it's that you no longer have to buy film, or remember to load or process it. Gone are the days of standing anxiously at the film counter wondering which kind of film to buy. Digital cameras record images onto tiny memory cards that can be erased and reused hundreds, or even thousands of times.

Shoot as Many (or as Few) Pictures as You Want

Gone, too, are the days of leaving a roll of film from your summer birthday bash in the camera until you finally finish it up during the winter holidays. With a digital camera you can shoot one picture or hundreds before you download them—it's entirely up to you. Your only limitation is the size of your memory card.

Review Pictures Instantly

Unlike with film, where you had to wait hours or even days before you could see a print or a slide, digital pictures can be viewed instantly on the LCD monitor of your camera. The LCD monitor is a tiny screen that can display your photos immediately after you shoot them. You'll know if you got the shot an instant after you snap the shutter and, on most cameras, you can even zoom in on the image to check details such as sharpness. If you've ever shot a group portrait and ended up with a bunch of half-closed eyes and turned heads, you'll love the ability to instantly review your digital pictures. Quickly check your shots and, if you don't like what you see, re-shoot immediately (after, of course, discretely telling your subjects that the missed shot was all your fault).

Compose More Carefully

Most digital cameras allow you to use the LCD monitor as a "viewfinder" while you're shooting. Because the LCD monitor shows exactly what the lens is seeing, you can use it to get very precise compositions. This can be particularly important with close-up photography where there is often a significant difference between what the optical viewfinder sees and what the "taking" lens sees, which can throw off compositions. With an LCD monitor, what you see is exactly what you get. Are you standing too far from your subject? Is there too much clutter in the background? Is your shooting angle too predictable? A quick glance at the LCD monitor tells the whole story.

Be More Experimental

Let your creative spirit run wild! Since there aren't any processing costs for digital images, you can shoot as many pictures as you like without suffering the guilt of "wasting" film. Digital pictures cost nothing to shoot. As long as you have enough memory space (see page 21), you can experiment and try things you might not otherwise be comfortable trying if you were paying for each shot. Nothing breeds creativity like knowing that all those experiments won't run up a huge processing bill afterward.

Delete the Clunkers

And remember, no one has to see the creative experiments that go too far afield. Digital cameras provide the unique ability to instantly delete the images you don't like. If you happen to shoot a real clunker you can just "trash" it immediately—you don't even have to download it. Being able to delete images also comes in handy when you find that you're running out of space on your memory card. By pruning out some of the weaker pictures, you can keep right on shooting.

> **Caution:** *Unless you're desperate for card space, don't be too quick to ditch your pictures in the field. Generally, you're better off making the decision to save or trash images back at the computer; a lot of times I find that my pictures look better on the large screen than I thought they might.*

Throw Away the Shoeboxes

If you're like most photographers, you've got
a shelf (or shelves) overloaded with shoe-
boxes full of "almost" images—pictures
that didn't make the grade for the fam-
ily album. Digital extras, on the other
hand, take up very little room. You
can store them on your home
computer or burn them to CDs
or DVDs for storage (see pages
90-91) and they'll always be
there if you want to review,
email, or print them. Plus,
you can scan your old pho-
tos and make them into digi-
tal files! You'll never need
those shoeboxes again!

Save Money

You no longer have to spend money paying labs
to print every shot on the roll, or filling up shoeboxes with those near miss-
es. You get to decide which photographs you want to print and enlarge
without paying for envelopes full of pictures you'll never look at again. Your
friends will think you're a wonderfully talented photographer because all
your shots will be winners!

Fix Your Flaws

You've probably heard or read a lot about "image-processing" software, and
it's one of the most fun parts of digital photography. Even very basic image-
processing software lets you do things like eliminate red-eye and adjust
color balance, brightness, and contrast. You can even improve the sharpness
of your pictures.

　　　　Let's say you shot a candid portrait of your kids on the backyard
swings on a really cloudy day and everything in the photo looks too blue.
With just a few clicks of the mouse, you can fix that blue color cast and
bring instant warmth to your cloudy-day pictures. (With a little practice,
you'll even be able to change the color of the shirts they're wearing—or get
rid of the garbage cans sitting next to the swings!)

Enhance Your Photos Creatively

If you're never seen a demonstration of what an image-processing program can do, you're in for a mind-bending creative surprise. Like a digital genie uncorked from a sorcerer's imagination, image-processing software lets anyone turn photographic reality inside out (and then some). Bored with green grass and blue skies? No problem—how about pink grass and a purple sky? Tired of rectangular buildings? Gone! You can make them wave in the wind, or remove them altogether. In fact, there is almost nothing that you can picture in your imagination that these programs can't enable you to do with a bit of practice and experimentation on your computer.

Kodak offers a free image-processing program called *Kodak EasyShare* software. It comes with their cameras, but you can also download it from their website. Just go to www.kodak.com.

Organize Your Pictures

One of the great things about having your photos in a digital format is that you can use your computer to organize them—and you'll need the help! In my first year of shooting digitally, I put more than 10,000 photos on my hard drive. Fortunately, there are some great software programs that help you organize your photos into albums, then sort them by things like keywords, titles, and even star-rating systems.

Kodak EasyShare software provides a number of simple methods for organizing and finding your images. Photos can be placed into albums and organized by subject or date. You can also assign captions to the photos or tag them as "favorites" and sort them by that criteria. The great thing about this software is that you can devise a system that organizes and locates images in a way that you find comfortable.

Make Your Own Prints

Nothing about digital photography is more creatively liberating (or addicting) than the ability to make prints right from your desktop. If you have a computer and an inkjet printer, you can make prints and enlargements that rival those from the best photo labs. Plus, unlike the film and darkroom days where you needed to have a big investment in time and equipment to make your own prints, making digital prints with your desktop printer is clean, fun, and fast. Best of all, anyone can make great prints at home with just a little practice. I've had great-grandmothers in my digital photo classes learn to make gallery-quality prints, so you can, too!

Share Your Pictures

Nothing beats the extraordinary ability to share your photos with friends and family around the world via email in just seconds. Think about the fun of sharing photos of your gardens in New England with pen pals halfway around the world! It only takes a few keystrokes. You can also post select images on free online galleries, and then friends anywhere in the world can view the photos and even order prints. Could anything be cooler than that?! (See page 90 for more about online galleries.)

Create Digital Scrapbooks

If simply sharing pictures isn't enough for you, check out the hot new hobby of digital scrapbooking. Using easy-to-learn scrapbooking software programs, you can turn your trip to Europe into a colorful and beautifully designed journal, complete with thematic pages, journal pages, headlines, and even great special effects. Best of all, numerous websites offer hosting for your creations so you can share them with friends near and far. And of course, you can also print the pages and put them into a traditional scrapbook for your digitally-challenged friends.

Digital 1
Camera Basics

What You'll Need

Now that you know what you can do with your digital camera, let's learn how to get started. In order to shoot, edit, and print digital photos, you'll need just four things: a digital camera, image-processing software, a computer, and a photo-quality inkjet printer. But, since there are labs that can edit and print your photos for you, all you really need to get started is a digital camera. While the technology surrounding digital cameras might make them seem daunting at first, essentially, digital cameras are very similar to the film cameras you are used to using. If you can take pictures with a film camera, you can take them with a digital camera—and you'll probably enjoy the results much more.

Inside a Digital Camera

All cameras—film or digital—consist of three common elements: a lens (for gathering and focusing light), a dark box (where the light is focused), and some means of storing that light—which in the case of digital cameras is a tiny computer chip that records the image. Two different types of chips are used in digital cameras: either a CCD (charged couple device) or a CMOS (complementary metal oxide semiconductor). Both types of chips use a veritable forest of miniature electronic circuitry to convert light images to digital signals that your computer can interpret and display as photographs.

© Eastman Kodak Company

Camera Types

If you've spent any time flipping through photo magazines or window-shopping at the camera store, you know that digital camera choices multiply like digital rabbits. Essentially though, all of these cameras can be placed into one of these three loosely defined groups: compact digital cameras (point-and-shoot), advanced digital zoom cameras, and digital SLR (single-lens-reflex) cameras, also called D-SLRs. Each type of camera has its own unique advantages, and in the following pages we'll take a look at each of these three groups.

Compact Digital Cameras

If simplicity, ease-of-use, and small size are high on your list of important camera qualities, then compact digital point-and-shoot cameras were made for you. Typically, these cameras provide fully automatic exposure and focus, a built-in flash, and a modest 3x optical zoom lens in a package that's smaller than a deck of playing cards. (See page 34 for more about optical zoom.) Most compact digital cameras have both an optical viewfinder and an LCD monitor that can be used to compose your pictures. These cameras also usually come with a built-in flash. While many offer a variety of exposure scene modes (see pages 44-48 for details), most lack the more sophisticated exposure controls that advanced digital zoom cameras and D-SLRs offer.

Image Sensors

Sensor chips for digital cameras vary in size from manufacturer to manufacturer, and even among various models from the same camera maker. In general, all other things being equal, the larger a sensor is, the better its image quality will be. A larger sensor usually means that the individual pixels are also larger and are thus able to gather more light and color information than smaller pixels on smaller sensors.

Sensor size also affects your camera's focal length multiplication factor (see page 32), though this is only relevant if your camera has interchangeable lenses. For most digital camera owners, you really don't need to know how large your camera's sensor is—it's unlikely to come up in any conversation other than this one!

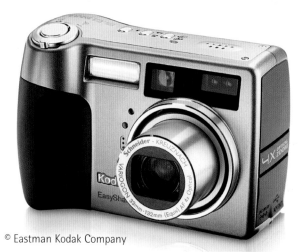

© Eastman Kodak Company

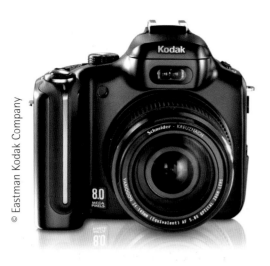

© Eastman Kodak Company

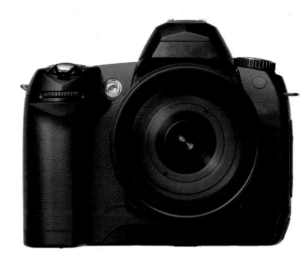

Advanced Digital Zoom Cameras

These cameras provide many of the professional exposure and metering options that digital SLR cameras offer, while maintaining the shooting ease and simplicity of compact digital cameras. Many of these cameras offer TTL (through-the-lens) viewing—you see exactly what the lens is seeing when you look through the optical viewfinder. Also, many have much more extensive optical zoom ranges (up to 12x), but unlike D-SLR cameras, they don't have interchangeable lenses. These cameras are designed for serious hobbyists who want more in the way of exposure control and optical flexibility than basic compact digital cameras can offer.

ELF Viewfinders

Most advanced compact digital zoom cameras feature a video-type viewfinder called an "ELF," or electronic viewfinder, that shows you a video display of what the lens is seeing. Using an ELF takes some getting used to, and some people just don't like them, so it's something you should try before you buy.

Digital SLRs

Digital SLR cameras represent the pinnacle of both technical and creative control in the digital camera family, and they offer one feature that no other type of digital camera provides: the ability to change lenses. This unique feature puts the entire range of camera lenses, from ultra-wide angles to super telephotos, literally at your fingertips (provided your pockets are deep enough to support such a luxury). Also, D-SLRs use a complex system of mirrors and prisms (as opposed to the ELF electronic display) so that what you see in the viewfinder is exactly what the lens is seeing— which can be a very big creative advantage. Keep in mind though, that almost all cameras in this category do not allow you to use the LCD monitor to compose a picture. That aside, D-SLRs offer the most extensive range of metering and exposure controls, as well as access to a mind-boggling range of accessories.

"Live" LCD Monitors

Both compact digital point-and-shoots and advanced digital zoom cameras have what is called a "live" LCD monitor. Live LCD monitors can be used instead of the camera's viewfinder to compose a shot. In other words, when you're getting ready to photograph your subject, you will see that subject live onscreen if your LCD monitor is turned on.

On digital SLR cameras (D-SLRs), however, the LCD monitor can only be used for reviewing images—it is not "live," therefore you cannot compose a picture using the LCD monitor instead of the viewfinder. The reason for this is simple: On D-SLR cameras, when you look through the viewfinder you are actually looking through the lens (not just through a window above the lens, or at an electronic representation of the image displayed by an ELF viewfinder—see page 17). The mirror that allows this to happen blocks the sensor's view of the scene until you are ready to take the shot. It is only when you press the shutter release button that this mirror flips up and out of the way so that the sensor is exposed to the image.

Cell Phone Cameras

Strangely enough, some of the most popular digital cameras are only cameras as a secondary thought. Many cell phone makers, for example, have exploited similarities in digital technology to add built-in cameras as a special feature. Most cell-phone cameras can record both still and video images, and you can use the phone's LCD screen for playback. Plus, since many cell phones have email capability, you have the option of immediately emailing your photos to friends. So now you can call someone from the Grand Canyon and not only describe the view, but email it instantly. The world is definitely getting smaller!

Camera Resolution

One of the main ways that digital cameras are described is in terms of their resolution, or how many pixels they have. Cameras with more pixels (theoretically, at least) take sharper-looking pictures with better tonal gradations and richer colors.

Pixels and Megapixels

Of course, talking about pixels naturally begs the question: What exactly is a pixel? The sensor in your digital camera (which is about the size of a dime in most cameras) is made up of millions of microscopic light-gathering cells called photosites or, more commonly, pixels (short for "picture elements"). A camera's resolution capability is measured in megapixels or millions of pixels. A 5-megapixel camera, for instance, has roughly five millions pixels on its sensor.

How Pixels Work

If you've ever looked at a pointillist painting by the artist Georges Seraut, you already have a good idea of how the pixel concept works. Each pixel captures and records a separate point of brightness and color. Using a visual blending system that is very much like that used by Seraut and other pointillist painters, digital cameras turn these millions of dots of light into very realistic photographs.

How Many Pixels Do You Need?

Generally the more megapixels a camera has, the better its image quality will be, and the more expensive the camera will be. Pixels alone don't define digital image quality, but just as with a pointillist painting, the more dots the artist uses (or the more pixels the camera uses) the subtler the transitions between colors and tones will appear. The number of megapixels you record an image with will also determine the maximum size print you can make. The chart below will give you a general idea of what maximum standard print size you will be able to make with your camera when printing at 300 dpi or 150 dpi. How far can you lower the dpi and still get an acceptable print? As a rule of thumb, you don't want to go below 150 dpi, but it pays to experiment. Try printing an image at 300 dpi, 200 dpi, and 150 dpi, then compare the prints to see the difference in quality. How much difference in quality you observe has a lot to do with the distance from which you view the print: The farther you stand from the print, the more acceptable low resolution prints become.

Resolution	Megapixels	Print Size at 300 dpi	Print Size at 150 dpi
1200 x 1600 pixels	2.1	3.5 x 5 inches (B7)	8 x 10 inches (A4)
1536 x 2048 pixels	3	4 x 6 inches (A6)	8 x 12 inches (A4)
1600 x 2400 pixels	4	5 x 7 inches (A5)	11 x 14 inches (A3)
2448 x 3264 pixels	8	8 x 10 inches (A4)	16 x 20 inches (A2)

More About Resolution

One topic that you simply can't escape from in digital photography is resolution. The problem is that, in the digital world, there are several different kinds of resolution. The three main types of resolution that you will encounter are camera resolution, image resolution, and print resolution. Here are some simple explanations:

Camera Resolution: Camera resolution is measured in terms of the total number of pixels that a camera is capable of recording an image with. For example, a 4-megapixel camera might produce an image that measures 2272 pixels wide by 1704 pixels tall, or 3,866,944 pixels in total (roughly four million pixels).

Image Resolution: Now to confuse things a tiny bit, images displayed on your computer monitor have a resolution that's measured in a different way. Image resolution is described in terms of ppi, or pixels per inch. In other words, image resolution describes how many pixels exist per inch of the image on the computer screen. Typically, website images, for example, are displayed at 72 ppi, or 72 pixels per linear inch of screen.

Print Resolution: Printer resolution is described in terms of dpi, or dots per inch, and refers to the number of microscopic droplets of ink per linear inch of printing surface. The standard for high-quality prints is 300 dpi.

Note: Despite the important differences between image resolution and print resolution, you should be aware that most people refer to both image resolution and print resolution in terms of dpi.

Image Resolution

Digital pictures are also often described in terms of their image resolution, or the number of pixels a particular picture has both horizontally and vertically. For example, a picture made with a 5-megapixel camera could be described as having a resolution of 2560 x 1920 pixels. What this means is that there are 2560 pixels across the long dimension of the image, and 1920 on the shorter dimension. If you were to multiply those numbers together, you would get (have you guessed this part already?) approximately 5,000,000 pixels—or five megapixels (okay, 4,915,200 pixels to be exact).

Memory Card Types

There are several different memory card formats available, but you'll need to purchase ones that are specifically designed for use with your camera. Some cameras provide dual slots that allow you to use more than one type of memory card (an option that seems of dubious value to me). Among the types of cards available are CompactFlash, Secure Digital, Memory Stick, SmartMedia, xD, and Microdrive. Keep in mind that these are different card types, not brands, and many companies manufacture each type of card. No particular format is better than any other in terms of picture quality or reliability.

What Size Memory Card Do You Need?

The amount of memory that you need depends on two important things: one, what size files your camera creates, and two, how many pictures you expect to take. It's always better to have more memory than less because, once you fill up your memory cards, you have to stop shooting. Imagine your dismay when you're shooting photos at the beach and a double rainbow soars across the sky right after you've used up your last memory card.

Since taking digital pictures is essentially free, you will probably shoot many more photos than you think you will. I began shooting digitally with a single 256MB card and now own several gigabytes worth of cards.

Memory Cards

Once your digital camera has captured an image, it needs a place to store that image so that it can get ready to take more pictures. Memory cards are small computer chips that slip into your camera and can hold anywhere from a few dozen to hundreds of photos, depending on the capacity of the card. Typically, cards come in a range of sizes from 32MB (megabytes) up to several gigabytes (GB). The more memory you have available, the more photos you can shoot before downloading.

Battery Saving Tips

- Try to keep batteries warm in cold weather because cold temperatures cause batteries to quickly lose their charge. Carry your charger with you when traveling so that you can recharge batteries overnight.

- Use the LCD monitor sparingly for composition. It drains batteries quickly, so the less you use it, the longer your batteries will last.

- Wayne's World aside, try to avoid unnecessary zooms. Excessive zooming of the lens drains batteries. Try not to zoom constantly, particularly if your batteries are running low. This won't give the battery back more power, but it may buy you a few extra shots.

- Don't leave the flash in its "always on" position if you can help it. Using the flash when you don't need it quickly saps battery power.

Card Capacity

Because all cameras create different size files, there is no hard and fast formula for estimating how many pictures a particular card will hold. However, if you know the size of the file your camera creates in its maximum resolution mode, you can divide the total capacity of a particular card by your camera's largest file size into to see how many best-quality photos the card will hold. For example, suppose your manual states that your 5-megapixel camera creates 3MB (three megabyte) files when you shoot using its maximum resolution mode. If you have a 256MB card loaded into your camera, that means you can shoot roughly 85 best-quality photos before it's time to download.

Inserting and Removing Memory Cards

Inserting a memory card into your digital camera is simple—just open the card door and pop it in. Read your camera's manual to be sure the orientation of the card is correct. Never force the card into the slot and always be sure not to touch any bare metal contacts on either the card or the camera. Refer to your camera's manual for card removal procedure, as well. Some cameras have a button you can push to release the card, while others simply require you to press down on the card itself and it will pop up for you.

Card Durability

Memory cards are exceptionally durable and can take considerable abuse. It's important, though, not to get the cards wet or let dust get inside them. Store them in a card wallet when not in use.

Batteries

Other than being an interesting conversation piece (or perhaps an expensive paperweight), your digital camera is essentially useless without batteries. It's a good idea to carry at least one (and preferably several) extra batteries with you—particularly if you're away from home—because once the batteries go dead, your shooting day is over. Most digital cameras come with rechargeable batteries that need to be charged regularly. All *Kodak EasyShare* digital cameras can be fitted to a *Kodak EasyShare* dock that both connects your camera to your computer or a *Kodak EasyShare* printer dock and automatically recharges the battery. Once you place your camera on the dock, the camera begins to recharge automatically.

Inserting Batteries

Be sure the polarities ("positive" and "negative") of your batteries are aligned properly to the symbols in the battery slot when you're inserting fresh batteries. You'd be surprised how often cameras are returned to camera shops as "not working" when the only thing wrong is the position of the batteries.

Getting 2 Ready to Shoot

One feature that is unique to digital cameras is the interactive menu system that provides access to many of your camera's operating modes and features. The advantage of menus is that they eliminate the need for lots of dials and buttons and, although they can be obtuse (not to mention frustrating) at times, using them makes it possible to quickly and accurately select or alter camera settings. In many cameras, menus appear both on the LCD monitor and in the optical viewfinder. The menus are often are activated by pressing a "menu" button on the back of the camera.

Navigating Camera Menus

If you've never used them before, navigating camera menus can be a bit like hopping down a digital rabbit hole—things are never as you expect them to be and choices seem to come and go very quickly. Fortunately, the odds are that you'll only use a fraction of the available menu items, so don't be intimidated by the sheer number of choices.

Menus are usually navigated via a master control dial that lets you move up, down, left, or right. Though the specifics vary from manufacturer to manufacturer (and even from model to model), digital camera menus are generally divided into several categories that include such headings as Camera Settings, Memory Card Setup, Flash Modes, Advanced Camera Settings, Playback Options, and File Numbering and Dating. Before you shoot for the first time, it's a good idea to study the menus with your camera manual in hand.

Setting Time and Date

The first time that you insert a battery into your new camera, you'll be prompted to set the correct time and date using a menu on the LCD monitor. This is a step that you shouldn't ignore because the information will get transferred to your computer when you download your picture files, remaining with them as a part of the data for each photo. Being able to look back months, or even years from now and know exactly when you shot each photo is a great benefit.

Date Stamp

Incidentally, time/date data is "hidden" in the image file so that you can locate it when you need it—it's not imprinted on the image itself. Most cameras also have an optional "date stamp" function that prints the date right in the photo. Once it's there though, it's a part of that image (unless you erase it using image-processing software).

Picture Numbering

Another choice you'll be offered when you first set up your camera is how you want to number your images. In most cases, the camera will simply number your photos consecutively as they are taken. For example, your camera might number your first photo as 100_001.jpeg and the next as 100_002.jpeg, etc. Even when you change memory cards, the camera will continue numbering where it left off. It's possible, however, to set most cameras so that the numbering begins anew each time you insert a card. If you do that, though, you risk overwriting older pictures when you download new ones that have the exact same numbers.

Overwriting

When one file is erased by another file with the same name, this is called overwriting. As described in the Picture Numbering section on page 26, it is possible for overwriting to occur when your camera is programmed to reset picture numbering each time a memory card is inserted. When you download the newest set of pictures, you could be overwriting the last set if the images share the same set of numbers. This is easily avoided by keeping your camera on continuous numbering.

However, this is not the only way that overwriting can occur. Whenever you open an image in your image-processing software and make changes, be aware that, if you want to retain the original image file, you need to change the altered image's file name before the first time you click Save. If not, you will overwrite the original image with your altered one. To avoid this, as soon as you open an image you plan to alter in your image-processing program, go to the File tab and scroll down to Save As. If the image is called Birthday.tif, you can call the new file Birthday2.tif, or Birthday_EDIT.tif. You will avoid overwriting the original, and you will easily be able to tell which image is the altered one.

Choosing a File Format

One of the most important menu items that you'll encounter is the one for choosing a file format for recording your images. A file format is nothing more than the particular method that you tell you camera to use to store digital information. The most common file formats are JPEG (.jpg), TIFF (.tif), and RAW (.raw, or a manufacturer-specific extension), and though much heated debate takes place in photo magazines about which is best, for most of us the JPEG format is made to order. In fact, it's so ideal that some camera manufacturers (like Eastman Kodak Company) offer it exclusively on certain camera models.

Common File Formats

JPEG is a fast, friendly format that uses moderate compression (see page 28) to shrink images so that they take up less memory card space.

TIFF images are very high quality uncompressed images that offer great picture quality but are slow to work with and take up lots of memory.

RAW images use little to no in-camera processing. Professional photographers who prefer to make all technical adjustments in the image-processing stage favor the RAW format.

JPEG Compression

Digital images create huge files that can bog down both your camera and your computer. In order to speed up the handling of images (and to keep memory requirements minimal), your camera uses what's known as "compression" to shrink images to a more manageable size. The most common type of compression is known as JPEG (short for Joint Photographic Experts Group, if you're a trivia buff). Your computer is able to read compressed images and return them to their larger size. However, bear in mind that JPEG is a "lossy" format. In other words, each consecutive time that you save a JPEG image, some minimal amount of information will be lost. To avoid this, save the file as a TIFF (which is not a "lossy" format) once you download it to your computer (if your software program allows you this option—some don't).

Virtually all digital cameras offer a choice of compression levels, and it's important that you use the least amount of compression available (i.e., the highest quality choice). While some image quality is lost during JPEG compression, as long as you use the least amount of compression possible in-camera, you will never notice a decline in quality. The great thing about compression is that it is handled automatically and you don't need to know a darn thing about how it works for it to do its job.

Image Quality

In addition to file format, many cameras allow you to adjust what is called "image quality." When you shoot JPEGs, your digital camera uses a compression scheme to shrink the images so that they are easier and faster for the camera to manage, and so that more can fit onto your memory card. There is a catch, however: The rate of compression affects image quality. In general, it's best to use the least amount of compression (the highest quality setting) that your camera offers if you intend to print your images. Lower quality settings (higher rates of compression) will let you squeeze more images onto your memory card, but it will cost you picture quality.

Learning
About Lenses

3

S ince the lens is the eye through which your camera sees the world, you should have some knowledge of just how lenses work and how they differ from one another. With the exception of digital SLR (single-lens-reflex) cameras—which allow for interchangeable lenses—almost all digital cameras come with a built-in zoom lens that lets you adjust focal length (see below) at the push of a button or the twist of a lens barrel. Changes in focal length can have a profound effect on the look of your images.

Focal Length

Focal length is measured in millimeters and describes the angle of view of a particular lens. The bigger the number is, the "longer" the lens is said to be, and the more narrow its angle of view. The smaller the number is, the "shorter" the lens is said to be, and the wider its angle of view. Longer focal lengths also magnify distant objects more than shorter focal lengths do. If you double a lens' focal length from 100mm to 200mm, for example, you will double the size of your subject in the viewfinder. Shorter focal lengths take in a wider view of the world and make subjects seem farther away. Many zoom cameras will display the focal length you're using for your shot in the viewfinder.

The Focal Length Magnification

Because most camera sensors are smaller than a frame of 35mm film, lenses designed for 35mm film cameras have a focal length that is effectively longer when used on a digital camera. This is because the sensor is only seeing part of the image that the lens is creating. Imagine a picture on a 35mm film strip. Now imagine a small rectangle drawn inside of it. If you were to take only the portion of the image in the smaller rectangle and enlarge it slightly to be the same size as the film strip, the image from the smaller rectangle would look "zoomed in." (If this sounds confusing, don't worry about it! Just rely on your LCD monitor, where what you see is what you get.)

The difference between the focal length of a lens on a 35mm camera and that same lens placed on a digital camera is called the focal length magnification factor. If you have a digital compact or advanced digital zoom camera that does not take interchangeable lenses, it is not likely that you will need to use this information. If you have a D-SLR, however, knowing your camera's focal length magnification factor will help you to calculate the actual focal length of a given lens when used with your camera's digital sensor. If a D-SLR camera has a 1.5x magnification factor, for example, a 100mm lens has an effective focal length of 150mm when used on that camera body.

The benefit of the focal length magnification factor is that your lenses automatically become longer (without any loss in aperture speed)—which is great for wildlife and sports photographers. If you own a

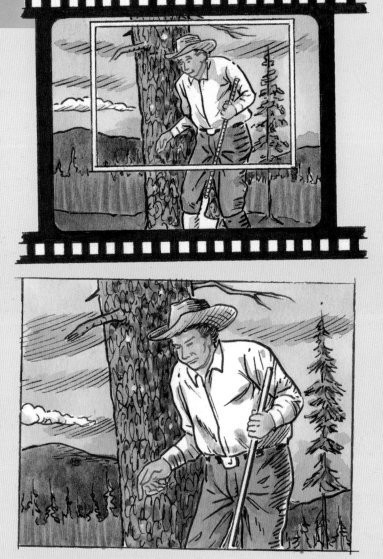

moderately long 300mm telephoto lens, for example, it would become a whopping 450mm lens on a D-SLR with a 1.5x magnification factor. Imagine sitting in the cheap seats at Fenway Park and getting great action shots of center field! The downside is that the wide angles are no longer quite so wide. An excitingly wide 24mm super wide-angle lens, for instance, becomes a rather mundane 36mm lens. Many manufacturers are now creating wide-angle lenses specifically for use with digital SLR cameras, but they're expensive.

Wide-angle focal lengths are perfect for shooting scenic vistas.

The 35mm Equivalent

One phrase you'll hear over and over again in discussions of lenses for digital cameras is "35mm equivalent." Actual focal lengths for lenses on digital cameras are different than those on 35mm cameras because the size of the digital sensor is typically smaller than a 35mm frame of film. However, since most of us are more familiar with 35mm lens focal lengths, manufacturers often describe lenses on digital cameras in terms of what the equivalent focal length would be if that same lens were used on a 35mm camera. This allows people to have some method of comparison—a reference point. In the following discussions, we'll use the 35mm equivalent focal lengths just to keep things simple.

Focal Length Categories: Normal, Wide-Angle, and Telephoto

Focal lengths that are between roughly 40mm and 58mm are called "normal" because the angle of view approximates what our own eyes see. When you take a picture at a normal focal length, distances and sizes appear very natural and "correct."

As you've probably guessed, wide-angle focal lengths are wider, or "shorter," than normal focal lengths. Because they have a wider angle of view, they make subjects seem farther away and smaller in size. You can exploit this quality to stretch and exaggerate subjects and the spaces between them. If you were to photograph a fishing pier at a wide-angle focal length, for example, you could make it appear to be considerably longer than it really is. Most digital cameras have a maximum wide-angle setting of about 28mm in 35mm equivalent. (The actual lens may be 18mm or less at its widest angle, but this number must be multiplied by the focal length multiplication factor—see page 32—to arrive at the 35mm equivalent of 28mm).

Telephoto focal lengths are those that are longer than the high end of the normal range (which is about 58mm). As focal lengths get longer, spaces and distance are compressed—and the longer the focal length of the lens, the more apparent the compression becomes. You've probably seen sports shots where the football players appear to be almost stacked on top of one another. That effect is caused by the photographer using a very long telephoto lens to take close shots of the subjects (while avoiding being tackled). Keep in mind, however, that even though telephoto focal lengths are great for bringing distant subjects—like wild animals and shy kids—up close and personal, the downside is that camera shake is also magnified. When shooting with focal lengths longer than 200mm, it's important to find a way to steady the camera. A tripod is the ideal tool for holding a camera steady, but a fence rail or a car will also work.

Zoom Lenses

The benefit of having a zoom lens is that you have a whole range of different focal lengths built into your camera. Most compact digital cameras have a somewhat modest zoom range of about 3x, which means that the longest focal length is three times greater than the shortest. A typical 3x zoom has a focal length range of 35-105mm, for example. Advanced compact digital zoom cameras may have zoom capabilities of up to 10x (38-380mm), or even 12x (38-456mm).

The creative advantage of having a zoom lens is that you can stand in one spot and alter your composition simply by changing focal lengths. But don't let the convenience of zooming keep you from using an even better creative accessory—a good pair of sneakers for walking closer to your subject.

Optical vs. Digital Zoom

Digital cameras often advertise two different types of zoom: optical zoom and digital zoom. The only zoom you need to pay attention to is optical zoom, which describes the actual zoom range of the camera lens. Digital zoom is nothing more than in-camera digital cropping. If your digital zoom is turned on, the lens will extend as far as it can, and then the camera will begin zooming in on the image digitally, which lowers the image quality. If you really want to zoom in on your subject farther than your lens will allow, you can crop the image later using image-processing software in your computer and do a better job than what the digital zoom feature offers.

Lens Speed

Another way that lenses are defined is by their "lens speed," which refers to the largest aperture of the particular lens. If your lens has a maximum aperture of f/4, for example, then f/4 is the speed of that lens. Lenses that have large maximum apertures are described as "fast lenses" and are usually more desirable (and more expensive) because they let more light into the camera. Fast lenses are particularly useful with low-light subjects.

Lens speed gets a teensy bit more complicated with zoom lenses because they often have what is called a "variable speed" aperture. What this means is that the maximum aperture of a zoom lens gets smaller as the focal length gets longer. So, for example, you might have a 35-150mm zoom with a maximum aperture of f/4-5.6. While the maximum aperture at 35mm is f/4, by the time you zoom the lens to 150mm, the maximum aperture "slows down" to f/5.6.

Macro Photography

Few subjects are more interesting to photograph than close-ups of things like flowers and insects. In fact, one of the more fascinating aspects of digital photography is that even very simple digital cameras possess a tremendous close-focusing capability. You can often get to within inches of tiny subjects to make terrific close-up photographs. To get the close-up shot of the blue glory-of-the-snow flowers shown here, my lens was less than an inch from the bud.

Auxiliary Lenses

Even though you can't remove or switch lenses on a compact or advanced digital zoom camera, you can broaden the focal length range with the use of auxiliary lenses. Most camera manufacturers make wide-angle and telephoto adapters that simply screw on to the front of your lens. Or, if you want additional close-up capability, there are also accessory close-up lenses available for many cameras.

Caring For Your Lens

The front surface of your lens is one of the most vulnerable parts of your camera. Not only is it made of glass and usually unprotected when you're shooting, but it's also the first thing to bump into a doorknob or get ice cream dropped onto it when you're out shooting. It's a good idea to cover or retract the lens when you're not actually taking a picture. It's also a good idea to periodically clean your lens. Use canned air to blow off loose dust, then use a microfiber cloth or lens tissue to very gently wipe the surface of the lens.

Getting 4
Good Exposures

I t's important that your camera captures just the right amount of light. If too much light strikes the sensor, your picture will be overexposed and look washed out. If too little light hits the sensor, your picture will be underexposed, appearing muddy and dark, and highlights will be gray instead of white.

It's Automatic, but...

Fortunately, the automatic exposure system in most cameras is very accurate and very reliable. So, in most situations, all you have to do to get a good exposure is set the camera to one of several autoexposure modes (see pages 45-48) and your exposures will be perfect. There might be times, though, when for either technical or creative reasons, you want to override the exposure settings chosen by your camera. In the following pages we'll look at how light is measured and which camera features control how exposure is set.

Light Metering

Thanks to the hard work of some very brilliant engineers, your camera uses an extremely sophisticated and precise light meter to measure exactly how much light is reflecting from any given scene. The camera then takes that information and selects the correct combination of camera settings to make a good exposure. There are a number of different types of built-in light meters, and some cameras provide a variety of metering options. Read your camera's manual to find out which metering options are available for your camera.

Despite all the electronic wizardry that makes up your camera, there are really only two camera settings that control the amount of light getting in: shutter speed and lens aperture. If you understand what each of these controls does and how they relate to one another, you will have a huge creative weapon at your command.

Shutter Speed

Shutter speed controls how long the camera's shutter remains open and, in turn, how long light is allowed to enter the camera. The longer you leave the shutter open, the more light enters the camera. Most digital cameras have a shutter speed range that goes from 30 seconds to as fast as 1/8000 second. Your manual will tell you exactly which speeds you have available.

Look at the chart of standard shutter speed choices below and you'll see a pattern: As you progress through the speed settings, each faster speed is twice as fast as the one before it. Similarly, each slower shutter speed if you move backwards through the chart is twice as long as shutter speed setting ahead of it. (The exception here is the stop between 1/60 second and 1/125 second, in which the speed is not exactly doubled or halved.) Each change in shutter speed is called a stop. (Changes in aperture are also called stops—see pages 40-41.)

Each time you go to the next faster speed, you halve the amount of time that light is allowed into the camera. Each time you go to a slower shutter speed, you double the time. The shutter speeds shown in the chart here represent the traditional shutter speed sequence, but many digital cameras use intermediate shutter speeds that fall between the traditional numbers, such as 1/750, for example.

Shutter Speed and Subject Motion

As you might have guessed, being able to adjust shutter speeds also has a creative application because the duration of the exposure time greatly affects the appearance of moving subjects. Long shutter speeds cause moving subjects to blur, while fast shutter speeds stop motion. The actual degree of subject blur or sharpness depends on several factors in addition to shutter speed, including how fast the subject was moving and your shooting position relative to the subject. The key thing to remember is that if you want a moving subject to blur, use a longer shutter speed; if you want to freeze the action, use a faster shutter speed.

Another advantage of using long shutter speeds is that you can keep the shutter open long enough (depending on your particular camera's capabilities) to record dark subjects or subjects at night. In this shot on page 39 of New York's Times Square, I kept the shutter open for a full second to record both the neon lights and the traffic streaks.

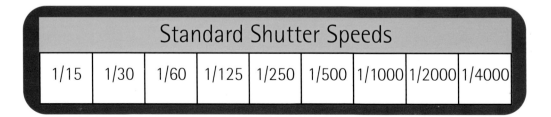

Standard Shutter Speeds								
1/15	1/30	1/60	1/125	1/250	1/500	1/1000	1/2000	1/4000

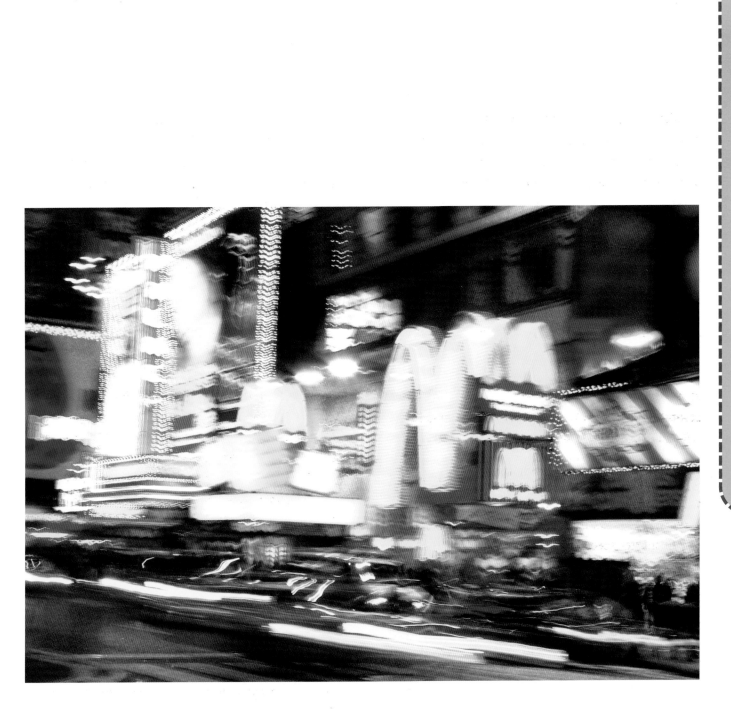

Lens Aperture

Though you're not likely to notice it unless you look directly into the lens as you take a picture (of yourself, presumably), there is a small iris-shaped diaphragm in the middle of you lens that opens and closes at the instant you take a picture. This diaphragm is known as the lens aperture and it controls the amount of light that reaches your camera's sensor. The larger the opening, the more light that enters the camera; the smaller the opening the less light that comes through. Just think of a hole in the bottom of a bucket—a small hole drips, a big one gushes.

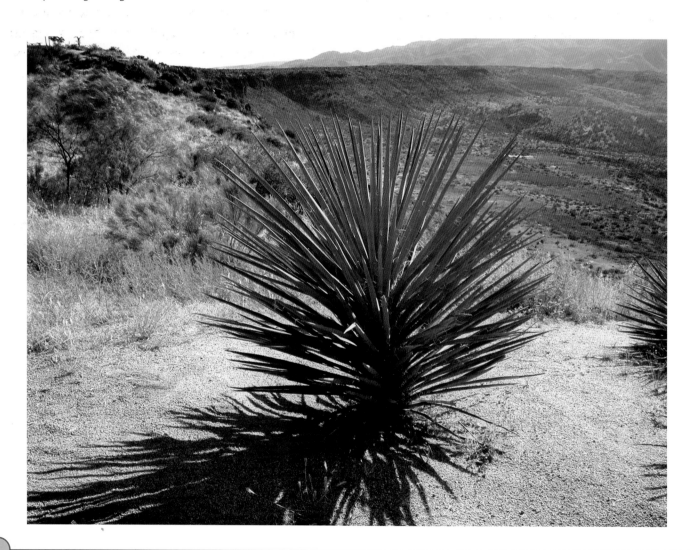

Aperture Settings

Like shutter speeds, aperture settings are also defined by a series of numbers—in this case they are called f/numbers (or in photo slang, f/stops). But here's the tricky bit with regard to f/stop numbering: The larger the f/number is, the smaller the opening in the lens. The smaller the f/number is, the larger the opening in the lens. A lens opening of f/16, for example, is relatively tiny when compared to an aperture of f/4.

If you have trouble remembering which apertures let in more light and which let in less, think of them as fractions: If one of your friends offers you 1/4 of a pie, they're giving you a lot more than if they only offer you 1/16 (in which case you would want new friends anyway). Of course, if fractions scare or confuse you, just ignore that analogy completely and remember the facts:

High f/numbers = smaller lens openings
Low f/numbers = larger lens openings

The chart below shows the typical progression of f/stops. The stops shown represent the traditional lens aperture sequence, but many digital cameras also use intermediate aperture settings that fall between the traditional numbers.

Note: Aperture numbers share the exact same mathematical relationship as shutter speeds do. As you move to the next larger lens opening (from f/5.6 to f/4, for example, which is moving one stop up) you double the amount of light entering the camera. Similarly, as you move to the next smaller f/stop (f/11 to f/16, for instance, which is moving one stop down) you cut the amount of light in half.

A Perfect Reciprocal Relationship

There is a perfect reciprocal relationship between f/stops and shutter speeds. In other words, if you cut the light in half by stopping down to the next smallest f/stop, you can still get the exact same exposure if you then adjust the shutter speed to the next slowest setting. What this means is that there is not just one combination of shutter speed and aperture that will yield a correct exposure, but an entire series of them. The chart on page 42 demonstrates this point. There are ten different exposure combinations that will all create the exact same exposure in terms of brightness. In other words, double both the shutter speed and the amount of light for one shot, then halve the shutter speed and the amount of light for the next shot, and both exposures will be equal.

Standard f/stops							
f/32	f/22	f/16	f/11	f/8	f/5.6	f/4	f/2.8

So why is one shutter speed and aperture combination better than another? Knowing that you can get the exact same amount of light into the camera with various aperture and shutter speed combinations opens up a wide variety of creative options. Think back to what we said about shutter speed and motion, for example. Imagine that you're photographing a diving competition and you want to stop the diver in motion mid-dive. By selecting a shutter speed and aperture pairing that favors a fast shutter speed, you can stop the action. Read on to find out why favoring a combination with a larger or smaller aperture may be best.

Equal Exposures					
1/15 at f/32	1/30 at f/22	1/60 at f/16	1/125 at f/11	1/250 at f/8	and so on...

Aperture Size and Depth of Field

Whenever you focus a camera, you focus on a subject at a specific distance from the lens. However, focus isn't like the edge of the earth in pre-Columbus days—it doesn't just suddenly drop off. In any given scene, there are areas in front of and behind your subject that will also appear to be in relatively sharp focus. Depth of field is the range from near to far in a photograph that appears to be in sharp focus, and it's a supremely important photographic concept.

Although there are other factors at work, the primary factor in determining how much depth of field a particular photo will have is the size of the aperture in use. Smaller apertures produce more depth of field and larger apertures produce less. A landscape shot at f/22 will have considerably more near-to-far sharpness than the same scene shot at f/5.6, for example. The focal length of the lens you're using and your distance from the subject also influence depth of field, but all other things being equal, aperture size will determine how much of a scene will be in sharp focus.

Manipulating Depth of Field

Depth of field is an important concept in all types of photography because it's one of the primary ways for you to put emphasis on important subject elements. In a portrait, for example, you may want to limit depth of field so that only the face of your subject is in sharp focus. In a landscape, on the other hand, you may want focus to extend from nearby elements (a tree in the foreground, for instance) to the horizon. Knowing what factors influence depth of field is very important. The following are the key elements that affect depth of field:

1 f/stop: The smaller the aperture, the greater the depth of field. To limit depth of field, choose a wide aperture (f/4 instead of f/16, for example).

2 Camera-to-subject distance: The closer you get to any subject, the less depth of field you have (with any given lens and aperture combination). If you want more depth of field, back away from the subject. If you want less, move closer.

3 Lens focal length: The shorter the focal length of the lens, the more depth of field you will get at any given camera-to-subject distance at any given f/stop.

ISO

The ISO setting on your camera controls the sensor's relative sensitivity to light. The higher the ISO number, the more sensitive you are instructing the sensor to be. You should select an ISO based on how much light you have available in a given scene. If it is a bright sunny day, you might choose an ISO of 100 or 200, for example. On a cloudy day, or in the shade, an ISO of 400 might be better. In low light situations (such as an indoor sporting event, for instance) you may want to raise the number to a higher ISO setting, such as 800 or 1600. The great part about shooting digitally is that you can change the ISO at the push of a button without having to switch to another roll of film to get the effect that you want. Try shooting the same scene at several different ISOs and review the results to see what works best. You can always delete the shots that don't work.

Noise

Higher ISO settings enable you to capture images in dim light, but they also create an inherent flaw called "noise." Noise appears as tiny dots of light or color that do not belong in the image. Again, experiment with the different ISO options available to you and see how low an ISO you can get away with and still capture a low-light image.

Higher ISOs allow you to shoot in low light, but they can also increase the appearance of digital noise in your image.

5

Exposure Modes

Technology is great, but getting a good exposure involves more than just recording a scene's tonalities correctly. There are creative (i.e., human) decisions to be made too: Are you shooting a landscape that requires an extensive amount of depth of field (see page 42)? Or are you shooting sports where you want to stop (or exaggerate) the action? Since telepathy has not been offered as an option, the camera has no way to know what you want to emphasize in a particular scene. So, to help you interpret different subjects in just the right way, virtually every digital camera offers a variety of auto-exposure options, or "modes."

Program Mode and Auto Mode

Virtually all cameras have a fully automatic exposure mode. In other words, the camera will automatically select an aperture and shutter speed combination based on the information gathered by the light meter. On some cameras this mode will be called Auto and on others it is referred to as Program—there are even some cameras that have both! The difference between Program and Auto is that, on some cameras, the Program mode allows you to "program shift," an option that lets you change the aperture or shutter speed while still maintaining the same

exposure value. (See the chart on page 42 for examples of different aperture and shutter speed combinations that produce the same exposure value.) In Auto mode you can only use the combination that camera has selected for you. Check your camera manual to see what options are available with your equipment.

Aperture Priority

When depth of field is an important consideration, this mode (usually indicated by "A" or "Av" on the mode dial) lets you select the appropriate aperture, and the camera selects the correct corresponding shutter speed. Since manipulating the range of sharp focus is such an integral part of my work, this is the mode that I choose most often. In fact, I would say that 80% of my photos are shot using aperture priority.

Shutter Priority

In this exposure mode (usually indicated by "S" or "Tv" on the mode dial), you select the shutter speed and the camera assigns the corresponding aperture. This is the mode to choose when stopping or exaggerating action is your prime consideration. As mentioned earlier, by selecting a fast shutter speed, you can freeze subject motion; by selecting a slower shutter speed, you can let the subject dissolve into a creative blur (see the photo on page 39).

Manual Exposure

If your camera offers manual exposure as an option, you may want to give it a try once you get more experienced in working with creative exposures. There will be times when—either for technical or creative reasons—you will want to override the camera's exposure recommendations. In Manual mode (usually indicated by an "M" on the mode dial), the camera's meter will display what it thinks is the correct exposure setting, but you must select your own aperture and shutter speed combination.

Exposure Limitations

When working using either shutter priority or aperture priority, in some extreme lighting situations you may choose an aperture or shutter speed for which the camera cannot select a correct corresponding setting. If you're trying to shoot on a very bright beach with a very wide aperture, for example, the camera may not be able to find an appropriately fast shutter speed. Or, if you're using a very long exposure time to blur a waterfall, for instance, the camera may not be able to find a sufficiently small aperture. The camera will warn you (usually with a blinking symbol) that you've gone beyond its capabilities for that scene, and you may get a poor exposure.

Scene Modes

In addition to the exposure options described above, many digital cameras also provide a host of subject-specific exposure modes usually referred to as "scene" modes. These modes are designed to provide an automatic exposure that is biased for certain shooting situations. Engineers must have a great time thinking up potential shooting situations because some cameras boast dozens of options! Typically, each mode is indicated by a graphic symbol on the mode dial, but scene modes may also be found in the internal menu system as menu options. The following are some of the more common scene modes:

Landscape: This is an excellent mode for landscape or scenic photography when you want to have lots of near-to-far sharpness. The camera gives priority to selecting a small aperture.

Portrait: Portraits often look best when the subject is sharp but the background is out of focus. In this mode, the camera selects a wide aperture to ensure shallow depth of field.

Sports/Action: When stopping the action is important, this mode lets you concentrate on following the action while the camera automatically selects the fastest available shutter speed.

Night Landscape: In this mode, the camera will choose a longer shutter speed than it would in daylight conditions. If you were shooting in New York's Times Square at night, for example, the longer exposure time would enable you to capture detail in dark areas, not just record the bright city lights. You'll probably need a camera support (such as a tripod) to keep the images sharp.

Night Portrait: If you're shooting portraits either indoors or outdoors at night, this mode will first fire a flash to illuminate your subject, then leave the shutter open to capture some background detail—a very useful mode if you remember to use it!

Close-Up: Most digital cameras—even tiny compacts—take exceptional close-up photos. This mode optimizes the exposure settings to provide just enough depth of field to keep tiny close-up subjects in sharp focus.

Fireworks: This exposure mode is intended to leave the shutter open long enough to capture one or more bursts of fireworks, but is also good for capturing city lights or streaks of taillights in traffic.

Panorama: It's possible with image-processing software to "stitch" together several images into one long panorama. In this mode, the camera helps you line up the segments necessary to create a seamless panoramic shot.

Tough Subjects and Exposure Compensation

The light meter in your camera is designed to create a good exposure from subjects of average brightness. Problems arise with very bright subjects, like snow or sandy beaches, or very dark subjects, like your black cat sitting on a dark blue car. Because your meter is trying to create an average exposure, it will turn both the snow and the black cat to a medium shade of gray.

If your camera has an exposure compensation feature, you can correct this flaw; add exposure to the bright scene that your camera would tend to underexpose, or subtract exposure from the dark scene that your camera would tend to overexpose.

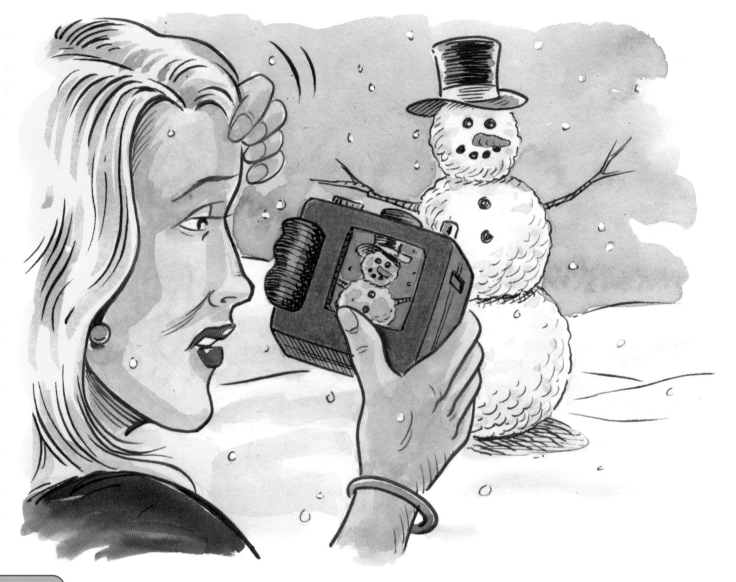

The Fine Art of Camera Handling

6

Your digital camera has a fantastically sharp lens and a very accurate autofocus system, but in order to get sharp pictures you still have to pay attention to two key things: holding the camera steady, and focusing with care. The following tips will help you to do just that.

Warm Heart, Steady Hand

Probably the single most frequent disappointment that most people have about their pictures is a lack of sharpness, or "blurry" shots. Most unsharp photos are due to an unsteady hand rather than a poor quality lens. In order for your pictures to look their sharpest, you have to take care to keep a steady hand (and, of course, a warm heart) when shooting.

Don't Jerk—Relax and Squeeze

When I was in high school I was on a rifle team and the one phrase I remember hearing literally hundreds of times is, "Squeeze the trigger, don't jerk it!" When it comes to snapping the shutter, the same thing applies: Gently put pressure on the shutter release button and you'll minimize camera shake.

Take a Deep Breath

People often transmit all their anxieties about taking photographs into their camera and, of course, it shows in the final pictures. Taking a photo is no time to get the jitters—after all, it's only a photograph. Plus, with digital, you can see your results right away and erase the shot if it didn't turn out how you wanted it to. Take a deep breath and hold it as you press the shutter and you'll tame your body vibrations noticeably. Oh, and don't forget to start breathing again after you shoot the picture!

Steady Stance

Most of us give about as much thought to how we hold a camera as we do to how we hold a baloney sandwich. There is, however, a bit of technique involved in holding a camera if your goal is to get sharp photos. Holding a camera steady begins with your feet: Try planting your feet a few feet apart with one foot slightly forward to keep your body from swaying when you're shooting.

Support the Camera

Since most shutter release buttons are pushed downward, it's important to support your camera from underneath with one hand while you operate the camera with the other. This technique works whether you're using the viewfinder or the LCD monitor to frame the shot. However, it is a bit easier to hold the camera steady if you're using the optical viewfinder because you can press the camera against your face.

Safe Shutter Speeds

The shutter speed that you're using has a significant impact on how sharp your photos will be. As a general rule, it's best to use a shutter speed that is the reciprocal of the lens focal length you're using for the shot. In other words, if you're using a focal length of 100mm, you can safely handhold the camera at 1/100th of a second or faster—if you shoot slower than that, you're risking camera shake. Also, you should generally keep shutter speeds at 1/60 second or faster regardless of lens focal length unless you are using a tripod or other camera support.

A Good Roost

It can get tiring holding a camera for long periods, but you can ease the fatigue if you get in the habit of finding convenient supportive surfaces for your camera during shooting. Fences, cars, and porch rails all provide a steady surface that will both help you shore up your stance and can greatly extend the range of safe shutter speeds.

Use a Tripod

Anyone who has ever taken a photo class with me will tell you that my eternal mantra is, "Use a tripod for every shot!" I realize that most people don't bother hauling a tripod around with them all the time, and there are times (like shooting the kids taking a bath) when a tripod can be more of a burden than a help. But overall, the single best way you can improve the sharpness of your pictures is to invest in a good quality, lightweight tripod and get in the habit of using it all the time. Here are some of the main advantages of using a tripod:

1 Tripods hold the camera rock steady at any shutter speed and make the full range of shutter speeds (and therefore apertures) available to you.

2 They prevent back fatigue, particularly if you're using a heavier camera model, such as a D-SLR with interchangeable lenses.

3 Working with a tripod slows you down, causing you to be more careful in considering design and composition.

4 By putting the camera on a tripod you can take multiple exposures of the same subject to try different techniques, such as experimenting with different shutter speed or aperture settings, or changing the white balance.

5 When you're shooting portraits, using a tripod allows you to frame the subject carefully but then stand away from the camera and converse more naturally with your subjects. When your subject strikes a good pose, just reach over and snap the shutter.

I shot the interior of the main conservatory at Longwood Gardens near Philadelphia using a monopod and an exposure of 1/4 second.

Monopods

There are a lot of situations where using a tripod is either impractical or impossible, and a monopod is a great alternative. A monopod is a one-legged camera support, and while it won't give you the complete support that you enjoy with a tripod, you will extend your "safe" shutter speed range by several stops. I often shoot in formal gardens and house museums, for example, where tripods are generally forbidden (they don't want you tripping the other patrons, I guess), but monopods are often allowed. They are also perfect for situations like a high school graduation

or a concert. Anytime there are a lot of people around and you need unobtrusive, mobile camera support, a monopod is a good choice.

Beanbags

Another alternative to using a tripod or monopod is to rest your camera on a homemade beanbag. You can make a beanbag for the price of a box of dried beans and a small piece of fabric. Just fashion the fabric into a small pouch, then fill it with

a good quantity of dried beans or peas and seal it up. You can lay the beanbag on a rock or any other sturdy surface, then "nest" your lens or camera body into it—and if you get tired shooting, you can always use it for a pillow.

Vibration Reduction

Last but certainly not least, one of the newest and most exciting technological developments in photography in recent years is vibration-reduction technology. It was first used in expensive pro SLR lenses, but is now available in many compact and advanced digital zoom camera bodies. Also called anti-shake or image stabilization, this technology uses various computer-guided systems to eliminate camera movement and substantially increase picture sharpness at slow shutter speeds.

Mastering 7
Light and Sharp Focus

How fast technology evolves! Barely a decade ago, camera manufacturers were still ironing out the last remaining technological autofocus wrinkles; today it's a nearly flawless and carefree technology. In most situations, you can aim and shoot and rely on the camera to provide a sharply focused picture. Good as it is though, there are still a few very common autofocus pitfalls and pointers to be aware of.

Watch the Indicators

On many digital cameras, you will see a pair of rectangular brackets in the center of the viewfinder (or on the LCD monitor) during shooting that indicate where the camera is focusing. It's important that you place these focus brackets over your main subject—a person's face if you're shooting a portrait, for example—so that the camera focuses on the correct part of the scene. A common mistake is to have the indicators on the background instead of on your main subject, and what you end up with is exactly that: a beautifully focused background and an out-of-focus main subject.

On many cameras, including virtually all of the *Kodak EasyShare* digital cameras, the autofocus brackets will adjust themselves automatically to try and closely match what the camera thinks your primary subject is. You'll notice that as you alter your composition—changing from a small central subject to a much wider off-center one, for example—the indicators will widen in order to try and focus on the important parts of the scene.

Off-Center Subjects

Having all of your important subjects dead center in the frame is not the most artistically inspired design plan. For the sake of an interesting composition, you might want to place your main subject off-center—either to the left, right, top, or bottom (or some combination of these possibilities). In order to let you do this while still maintaining focus, most digital cameras have an autofocus lock that is activated by pressing the shutter release halfway down.

Follow these three simple steps when focusing on an off-center subject:

1 Position your key subject in the center of the frame and press the shutter release button halfway down to activate the autofocus.

2 Without lifting your finger from the shutter release button, recompose your scene so that the subject is where you want it in the frame.

3 Press the shutter release button down completely to take the picture.

Difficult Autofocus Subjects

As reliable as autofocus is, there are some situations where your camera may have trouble finding a sharp point of focus. The following are some situations where you may find that your camera has difficulty focusing and some quick solutions for these occasions:

Manual Focus

Virtually all D-SLR cameras (and some advanced digital zoom cameras) have manual focusing capability, which lets you focus the camera either by turning the lens barrel itself or by using a focusing switch. Manual focus is a great option when the camera is having difficulty focusing with its AF system, or when you have a very small but important target in a complex scene—one face in a crowd, for example.

Autofocus Troubleshooting

PROBLEM	SOLUTION
Low Contrast: Many AF (autofocus) systems use scene contrast to help them focus, so a scene with very low contrast may present focusing difficulties.	Solution: Look for a contrast edge where dark and light areas meet and position the focus indicator brackets over this distinct point of contrast. (Refer back to page 57 for details on how to maintain focus while you recompose the shot.)
Fog and Mist: Fog and mist reduce contrast in landscape scenes making it hard for the camera to find a good focusing point.	Solution: Look for a dark subject—such as a tree or a sail boat—penetrating the fog or mist and focus on that.
Low Light: AF systems are designed to operate in low light, but in very dark situations the camera may have trouble locking focus. Many cameras have a focusing illuminator beam that sends out a grid of light that the camera "sees" and can focus on. Typically, however, the illuminator beam can only reach a distance of 12-15 feet (3.7-4.6 m), so its usefulness is limited to nearby subjects.	Solution: If possible, turn on more lights to raise the light level or use the camera's built-in flash. Try to find a bright subject—a lamp, for example—that is the same distance from the camera as your subject and pre-focus on that area. Then, use your focus-lock feature (if available) to maintain focus while you recompose the shot.
Moving Subjects: Moving subjects can be hard to focus on because your camera is designed to lock focus on stationary subjects. Some cameras, however, have a "continuous" focus mode that continually refocuses up to the instant of exposure.	Solution: Be sure to keep moving subjects within the focus-indicator brackets. Switch to a continuous-focus mode if your camera has one. (See page 38 for more about action photography.)
Patterns: Some AF systems are better at focusing on patterns than others (fence rails, for example). You may find that your camera balks when trying to latch focus onto a particular pattern.	Solution: Turn your camera on a slight angle so that the pattern takes a different position in the viewfinder. If that doesn't work, look for a small area of the composition that doesn't contain the pattern and focus on it, then recompose the shot.
"Blank" Areas: As sophisticated as it is, your camera can't focus on subjects with no details or contrast—such as a black cat in front of a dark wall.	Solution: Find an area with detail approximately the same distance from the camera as your primary subject and position your focus indicator brackets over that area. If you're photographing a black cat in front of a dark wall, for instance, be sure the focus indicators are over the cat and not the wall.
Shooting Through Glass: The problem with shooting through glass is that your camera will try to focus on the glass itself if there are any smudges or dirt on the surface. Reflections can be a problem, too. (Ironic, isn't it? Sometimes you can't get a camera to focus on a tree in the fog, but it can manage to find a finger smudge on glass.)	Solution: Be sure the glass is clean, then get as close to the glass as you can so that the camera isn't trying to focus on reflections. If your camera can take filters, use a circular polarizer, which can eliminate reflections. If you have a D-SLR, switch to manual focus.

Looking at Light

The most essential ingredient in any photograph is, of course, light. Without light, your camera would be little more than an expensive and useless indulgence (not to mention hard to find in the closet). But thanks to the sun and Thomas Edison (and the stars at night), we do have light.

We'll talk about artificial light in a few moments, but for now, let's look at natural daylight. The light from the sun does more than merely illuminate the world, it also decorates, sculpts, and colors it with its ephemeral moods—some subtle, some outlandish. As the earth turns and the sun rises and sets, the appearance of everything around us evolves perpetually. Learn to see and anticipate the changes in daylight and you will begin to unlock the true essence of photography.

Light Direction

As the earth spins around on its axis and the sun moves across the sky between dawn and dusk, the direction of the light hitting the earth changes. The way in which light strikes a subject relative to your camera position has a profound effect on both the subject's appearance and the mood of a photograph. Is the light falling on the front of the subject? Is it striking it from behind? From the side? Each lighting direction has its own unique qualities, advantages, and disadvantages, and once you become aware of them, you will be able to anticipate how changes in light direction will affect the look of outdoor subjects.

Front Lighting

Like a spotlight illuminating a Broadway stage, light that comes from the front has a bold and brassy feel to it. It can be very useful for igniting colors and revealing surface details. Subjects are front-lit when the sun is coming over your shoulder and landing flatly on your subject. While it provides a lot of light and is easy to expose for, subjects shot using front lighting often lack texture or a sense of depth.

Front lighting is not ideal for bringing out texture in a subject, but it is easy to expose for.

© Kevin Kopp

Top Lighting

Photographically, at least, the midday sun is probably the least attractive type of daylight. When the sun is high overhead, textures and subtlety disappear, people get shadows in their eye sockets and under their noses, and landscapes lose their sense of depth. But there is also a good side to top lighting; colors are very bold and bright, and it's usually easy to expose for top-lit scenes. Most professionals, however, use the midday hours to scout pictures and then return at a more "attractive" time.

Side Lighting

One of the prettiest times of day occurs when the sun is low and pale yellow light rakes side-to-side across the landscape. Side lighting happens twice a day—early in the morning and late in the afternoon—so you have two shots at finding it. Textures are at their best in side-lit scenes because the light is illuminating every little bump and dimple, and casting myriad tiny shadows. Exposure is a little trickier because of the added contrast. If your camera has an exposure compensation feature, try adding an extra stop of light (using the "+" button) to open up dark shadows just a bit.

Backlighting

Backlighting occurs when your subject is between you and the sun. Landscapes are particularly interesting when backlit because the long shadows advancing toward the camera enhance both depth and texture. The tough

Side lighting emphasizes textured details in a scene, but you may need to add a stop of light to compensate for dark shadow areas.

Backlighting causes long shadows to extend away from the subject and towards the camera. To avoid underexposure, you may need to add a stop of light.

part of shooting into the light, however, is that the scene can be contrasty and difficult to exposure for. Again, if your camera has an exposure compensation feature, adding a stop of light will keep scenes from being underexposed.

Edge Lighting
Edge lighting occurs when backlighting is particularly brilliant, giving thin, "translucent" subjects (leaves, fields of tall grass, your daughter's bouncing ponytail) a soft glow, and giving more opaque subjects (tree branches in winter, a person in silhouette) a gilded edge of illumination that is often quite dramatic.

Time of Day

If you want to learn how evocative light can be in transforming the appearance of a scene, just sit in a park some afternoon and watch as the daylight changes in its intensity and direction. From the unforgiving blast of overhead midday sun to the delicate wafts of buttery evening light, the slightest changes in the position of the sun radically alter the appearance of the natural world.

Scenes that appear humdrum and ordinary at noon can be mysterious and captivating as the sun drapes them in long yellow rays of morning or evening light. And few moments of the day are as beautiful as the brief slice of time when the sun is illuminating the morning sky with its rosy glow but hasn't yet cleared the horizon. Keep in mind, though, that the appearance of daylight changes faster at the beginning and end of the day, so you have to be ready to shoot when you see light that you like.

The Golden Hours
Photographers often refer to the first hour or so after sunrise and the hour or so before sunset as the golden hours because the sun at that time of day is very warm and, well, golden. Light is often softer and gentler during these hours also, which gives scenes a pleasing, romantic look. If you like Maxfield Parrish's illustrations, you'll love shooting during the golden hours. And if you really like backlighting but don't know what Parrish's work looks like, go look him up—you'll enjoy his vision and learn a lot about the beauty of natural light.

Light Quality

In addition to changes in direction and color, light also changes in its intensity throughout the day and as the weather changes. If you've ever sat on a beach under midday sun without a hat or an umbrella, for instance, you know just how harsh the light can be: Shadows are black, bright areas are obliterated, and there is little gradation between those two extremes. In bright sunlight, shapes are hard and edges appear sharp to the touch. The same beach on a mildly overcast day has an entirely different quality: Shadows are open and full of detail, tonal gradations are very gentle, and shapes seem soft and sensuous.

Hard Lighting
The brilliant light of a cloudless day can be harsh and unforgiving, but it is not altogether useless. Hard lighting can give colors a vibrant zest, and the deep shadows it creates can help to add texture and a three-dimensional feel to landscapes. But beware, the same extreme contrast range that makes it difficult not to squint, or to see without shading your

eyes, can also make it tough to get a good exposure. Often the contrast range on brilliantly lit days will exceed your sensor's ability to capture it.

Soft Lighting

Early or late in the day, or when the sky is slightly overcast, the light is softer and is very flattering to both landscapes and portraits. The softer the light is, the more even the tones will be in a scene, eliminating problems with both contrast and exposure. Because shadows are more open and highlights are less extreme, you will have a much higher rate of good exposures when the lighting is soft.

Also, while a cloudy sky may not be your favorite thing to see when you're off on a photographic outing, the diffused light of a cloudy day cre-ates a very pretty palette of muted pastel tones. Take a picture of a local park sometime in both hard and soft light and you'll get a good sense of just how much the quality of light can alter your perceptions of a scene.

Dramatic Light

One of the reasons for carrying your digital camera with you all the time is that dramatic lighting can erupt anywhere at anytime—and when it does, it literally transforms the landscape. The best time to look for drama in natural light is when a storm is approaching, or when a late-afternoon thunderstorm starts to break up. I shot this harbor scene below in Stonington, Maine just as a thunderstorm began to darken the sky; the sun was still lighting the foreground, but the drama was beginning to build.

Existing Light

Next time you're in a low-light scene, consider shooting by the existing light rather than using flash. Whether you want to shoot pictures of city streets at night, a stained-glass window inside a church, or even intimate portraits by candlelight, your digital camera is capable of taking wonderful photos using only the available light in a scene.

When light levels are relatively low, you will probably need to be shooting at longer shutter speeds, and a tripod will be necessary to keep the camera steady. You might also want to use a higher ISO setting (see page 43) to increase the camera's sensitivity to light.

Existing Light Indoors

It's tempting when you're shooting indoors to use your camera's built-in flash, but using flash often destroys the atmosphere of a scene. Instead, try to work with the existing light. Portraits taken by lamplight (or even candlelight) have a much warmer, more intimate appeal than those taken with flash, and they really aren't that hard to shoot.

Here are some tips for shooting indoors using existing light:

1 Boost the ISO if your camera allows it (some cameras adjust the ISO speed automatically when they detect you're working in a dimly lit setting).

2 Avoid including the light source itself in the shot since that will fool the camera's light meter into thinking the entire scene is brighter than it is.

3 Try to match the white balance (see page 66) to the type of existing light so that the colors look natural. Most lights use tungsten bulbs, so setting your white balance to the Tungsten setting will give your image natural-looking colors. Or, you can leave the white balance on the Daylight setting to intensify the warmth. (If your indoor scene has fluorescent lighting instead of tungsten, use the Fluorescent white balance setting, if available.)

4 Steady your camera! Use the arm of a couch or a tabletop if you don't have a tripod handy.

Outdoor Scenes at Night

Considering how exotic the nighttime landscape can be, it's surprising that more photographers don't take advantage of the opportunity. I find that shooting city landscapes in particular can be both inspiring and addictive. Exposure is flexible in most night scenes; in other words, you'll get good shots at a variety of exposure settings. The great thing about shooting digitally is that you can view your experiments instantly to see if you want to use a longer exposure or look for a scene with more lights.

Here are some tips for shooting outdoor scenes at night:

1 Use a wide-angle to take in sweeping cityscapes, or use a longer telephoto zoom length to "compress" lots of lights together.

2 Use the "night time" exposure mode if your camera has it. This will help to ensure that you're getting long enough exposures.

3 A tripod is great if you want sharp pictures, but don't avoid shooting if you don't have one handy. Sometimes jiggling the camera during a long exposure creates very interesting effects.

4 Try shooting at twilight when there is still some light in the sky but city lights have begun to come on.

5 After rain, look for streaks of color or sign reflections on wet pavement.

White Balance

In the film world, if you wanted your photos to look "natural," you had to match the type of film you used to the type of lighting you were using. Daylight film was used for outdoor photos during the day and tungsten film was used for shooting indoors. Almost all digital cameras, though, have a feature called "White Balance" that allows you to electronically (via your menu panel) adjust the sensor's response to the color of existing light.

If you simply use the Auto white balance setting, the camera will automatically adjust to what it thinks is the color of the existing light. But, in some situations, it's better to manually match the white balance selection to the type of light. Typical settings found in many white balance menus include: Daylight, Cloudy, Shade, Tungsten, Fluorescent, and Flash. Each setting, when used in conjunction with the corresponding type of light, will render the colors in your image naturally. You can also use these settings creatively to make a scene look warmer or cooler by choosing a setting that's different than the light you're shooting with. Experiment by shooting the same scene using different white balance settings and see what the effects are. Refer to your camera manual for more about your particular camera's white balance settings. They are very useful and, with a little pratice, are very simple to understand and set.

Using Electronic Flash

© Kevin Kopp

lectronic flash is a modern marvel; it's like having a small jug of bottled sunlight ready to uncork whenever the light gets too low. No matter how dark things get, flash can almost always provide all the light you need to get a good exposure. When I first began using electronic flash, there was still a substantial amount of distance measuring and aperture choosing involved. But today, getting a good flash exposure is as simple as just turning on the flash and shooting.

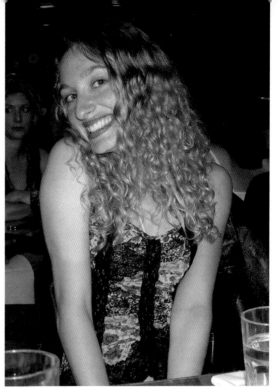
© Martha Morgan

Built-In Flash

Built-in flash couldn't be simpler to use, and in fact, on many cameras the flash will turn itself on whenever the camera detects there isn't enough existing light to get a good exposure. On other cameras, a flash indicator (typically a small lightning streak icon) will start to blink to let you know the camera thinks it's time to use flash (and who are you to argue with what your camera thinks?).

Built-In Flash Modes

Most built-in flash units can be operated in a variety of different flash modes. Each of these modes is designed to solve a particular lighting challenge or to help achieve a creative effect. While all of the flash modes will provide adequate exposure when matched to the correct subject or situation, it's important that you understand when to use these different modes. On some cameras, you can switch between flash modes using a simple dial; on others, it's a matter of pushing a button, turning a dial, using your menu, or some combination of these three methods. (Check your camera's manual for specifics.)

Here are some of the typical modes:

Auto: In this mode, the flash will turn on automatically when the camera determines that there isn't enough existing light. Exposure and very accurate provided you stay within the flash's range.

Always On: This is more or less an override mode that tells the camera you want the flash to fire regardless of the degree of existing light. This is a good mode to turn to when you want to use fill flash (see page 71) on a bright sunny day when the flash normally would not turn itself on.

Red-Eye Reduction: The mode fires a preflash, causing the pupil to shrink, thereby eliminating most cases of red-eye (see page 70). This mode should only be used when taking portraits of people or animals in low light.

Close-Up: Some cameras have a special close-up flash mode that provides just the right amount of exposure for close-up subjects. In this mode, the typical minimum flash distance is reduced so that it doesn't overpower close-up subjects.

Slow Sync: Often when you're shooting flash pictures in dimly lit situations the flash will provide enough light for your main subject but causes the surrounding areas to fall into darkness—not a very attractive combination. The slow-sync flash mode combines a bright flash with a longer than normal shutter speed so that the camera has time to record some of the background, thereby balancing flash and existing light.

Flash Off: There will also be times when you don't want the flash to turn on, even though the existing light is very low. If you're shooting city street scenes after dark, for example, the flash will give nearby subjects an unnaturally bright appearance. Turning the flash off means that you'll be shooting your scene using only existing light.

Flash Range

The one thing you have to be careful of is to remain within the flash's acceptable distance range. All flashes are designed to provide adequate lighting coverage within a certain minimum and maximum distance. If you use the flash on a subject that's closer than the minimum distance, you run the risk of overpowering your subject with light; if your subject is beyond the maximum range of the flash, it will be underexposed. Read your manual to be sure you know the minimum and maximum distances for your flash.

Ol' Red-Eye

It may sound like a drink that Wyatt Earp might order in a Dodge City saloon, but red-eye is actually the name of that eerie red glow that eyes get when they're photographed with flash. The effect is caused by the flash reflecting off of the retinal surface of the eye, and is worst when the flash is aimed directly at the subject. You can often reduce or even eliminate red-eye by turning on additional lights if available (which causes the pupil to contract, helping to eliminate the retinal reflection), or by shooting your portrait subjects from a slightly high or low angle. Most cameras also have a red-eye-reduction flash mode (see page 69) that uses a series of bright pre-flashes to shrink the pupils of your subject's eyes—that usually solves the problem. There are even some cameras on the market that can actually eliminate red-eye in-camera after the exposure is made.

Post-Production Fixes

Red-eye is easy to fix with even the most basic image-processing programs. Many of the programs that come with digital cameras have a function that is specifically designed for erasing the red-eye effect. Both animals and people can get red-eye, though with animals it's often a greenish blue glow instead of a red one. A squirrel I photographed recently had orange-eye.

Accessory Flash Units

While built-in flash is very convenient and more of a necessity than a luxury, it also has its limitations in terms of power, range, and creative flexibility. Many digital cameras can accept accessory flash units that attach via a "hot shoe" on the top of the camera (usually right above the viewfinder), and these provide

substantially more flash power. An average accessory flash unit has a distance range of twice or three times that of a built-in flash. Plus, many accessory flash units have a tilt head that allows for specialized flash techniques, such as bounce flash.

Fill Flash

It may seem like overkill to think of using electronic flash outdoors in bright sunlight, but that is actually one of its most useful applications. The harsh light of bright sunny days causes a major problem when taking pictures of people: dark shadows in the eye sockets and under the nose, lips, and chin. By using a flash in these situations, you can fill in these shadow areas with light. The idea is to use just enough flash to open the shadows; don't eliminate them entirely or the photos will look falsely lit.

Many digital cameras have a fill flash mode where the camera will automatically use just enough flash to open the shadow areas. Of course, you're still limited by the flash range (whether it's a built-in or accessory flash), but in portrait work, you will usually be work-

ing within that range anyway. If your camera does not have a fill-flash mode, just switch the flash on manually to make the camera flash in bright sunlight. Check the results on the LCD monitor and you'll see right away if your overall exposure needs adjustment.

Bounce Flash

One of the problems of using on-camera electronic flash as your primary light source indoors is that it tends to overwhelm nearby subjects while leaving more distant ones in the dark. If you're photographing your family around the holiday dinner table, for example, you end up blasting nearby faces into oblivion and underexposing more distant faces. If you have an accessory flash unit with a tilt head, however, you can use a technique called bounce flash by aiming the flash unit at the ceiling instead of directly at your subjects.

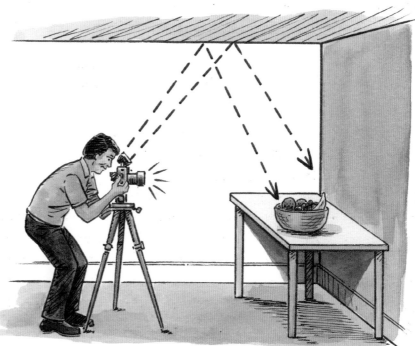

The benefit of bouncing flash from the ceiling is that it softens up the light while creating more evenly balanced illumination. Since most accessory flash units for digital cameras are dedicated TTL (through-the-lens) flash units, this means that the camera will measure the correct amount of light and shut the flash off when a good exposure has been achieved. Study your accessory flash manual for more information about bounce-flash techniques with your particular equipment. The following chart outlines some common flash problems and quick steps for solving them.

Common Flash Errors

PROBLEM	SOLUTION
Problem: Flash is reflecting from a glass surface or mirror.	Solution: Find an angle that avoids shooting directly into the reflective surface.
Problem: Flash is washing out the subject.	Solution: Be sure that you are observing the minimum flash distance.
Problem: The subject is too dark.	Solution: You are probably shooting outside of the flash's distance range. Get closer to the subject or increase the camera's ISO.
Problem: Members in a group of subjects are too dark.	Solution: The group is spread out over too great a distance range. Try to arrange the group so that the members are fairly equidistant from the flash.
Problem: Subjects have red-eye.	Solution: Turn on more room lights and/or activate your red-eye reduction flash mode (if available). Alternatively, shoot the subject from a high or low angle, or have the subject look away from the camera.

© Kevin Kopp

Taking Great Digital Pictures

9

Great pictures are about more than merely knowing how to use your camera—they are also about having interesting visual ideas. If all it took to take great pictures was to have an expensive camera, the world would be overrun with wonderful photographers! In this chapter, we'll take a look at some of the concepts that go into designing great images and putting your creative musings to work. Remember, when it comes to creative ideas, there are no rights or wrongs and there are no rules—but there are lots of tips and tricks to help you put your ideas into action.

Learn to See Creatively

No matter what the subject matter, beautiful pictures are the result of taking the time to truly consider your subject, learning to see beyond the superficial and look more carefully at the visual components that make up a scene. It's important to learn to see beyond the obvious. A pear ripening on the windowsill is just a piece of fruit to some, but to the gifted eye of the photographer, it can become a small world of interesting shapes, colors, and textures. To see the world as a visual artist does, you have to be prepared to step away from predictable views and seek out the beauty in common objects and scenes.

Countless books have been written about artistic composition and design, but all the elaborate theories in the world come down to one simple thought: Composition is the art of arranging things within the frame so that they have the strongest impact. Let's look at some simple methods for doing just that.

Choose a Strong Center of Interest

A photograph should be about one thing: a barn, a person, a piano, or even a person sitting at a piano in front of a barn. However, if you also include a cow and a farmer in that shot, you may have people wondering what you were trying to show. Be specific. You should be able to describe your photo in a very simple sentence: "This is a photograph of my cat sleeping in the window," rather than, "This is a photograph of my cat sleeping in the window next to my husband sitting in his favorite chair... and please ignore the pile of magazines on the floor next to him." Keep it simple. It should be easy for anyone looking at the photo to tell what your subject is.

Place the Subject with Care

It's so easy (and natural) to put a subject in the center of the frame that most people do just that. Like an archer going for a bull's eye, we nail the subject to the middle of the frame. But centering your subject creates equal amounts of space around it that makes for a very static design. Instead, try to place your main subject high or low in the frame, or to the left or right. The slight imbalance created by off-center subjects lures the eye into exploring the scene.

Simplify

The fewer things you include in the frame, the more powerful the things you do include become. Try to eliminate anything that distracts from your main subject.

Get Closer

One of the best ways to eliminate clutter and focus attention on your main subject is to simply move closer. As long as you're not shooting sailboats from the end of a wharf, take a few steps closer and you'll improve your images greatly. If you can't move closer physically (perhaps you are on the edge of a wharf), try using a longer zoom setting.

Use Frames within Frames

One trick that many landscape photographers use to eliminate distracting surroundings and focus attention on a subject is to surround it with an existing frame in the scene. Look for both natural frames (tree branches, rock formations) and manmade frames (window frames, open gates) that have a thematic link to your main subject—framing a cow in a barn doorway, for example.

Place Horizons to Emphasize Space

Where you place the horizon has a tremendous effect on how the division of space in the scene will be perceived. As the photos on the following page show, placing the horizon low in the frame emphasizes the sky; placing the horizon higher in the frame exaggerates foreground space. Most how-to books on composition will tell you to avoid putting the horizon across the center of the frame because it tends to create that static feeling I mentioned earlier when the space around your subject is divided equally. And that's true, but sometimes centering the horizon just seems to work in a particular composition, and the symmetry creates a pleasing sense of balance. Experiment with horizon placement for yourself and see what you think.

Horizontal vs. Vertical Shots

Just because your camera is designed to be held more comfortably in the horizontal position doesn't mean you won't improve your compositions by shooting vertically on occasion. In fact, lots of subjects—tall buildings, flowers, Trot Nixon reaching up for a fly ball—just look better when shot vertically. Often, it helps to shoot a subject both ways and decide later which is better, once you've downloaded the images. And don't forget, you can always crop a horizontal shot vertically and vice versa—these are your photos! You get to decide what looks best.

Cropping

One of the simplest ways to fortify most compositions is to crop away extraneous details—anything that doesn't add to an image detracts from it. If you've photographed your daughter sitting on a rock by the beach, for instance, you don't need to show the lifeguard station behind her. By cropping away superfluous material, you focus your viewer's attention on your main subject and eliminate doubts about what it is you're trying to show.

Cropping can be done to any size or shape, and it's perfectly fine to crop a rectangular photo into a square one or turn a normal landscape into a panoramic. But beware! When you crop a digital image, you're throwing away pixels and reducing the maximum size print you can make (see the print size chart on page 19). If a file was originally large enough to make a quality 8 x 10-inch print (A4), for example, and then you crop half of it away, you either have to settle for a smaller print or a larger print at a lower resolution. Be sure to save your original un-cropped file just in case the cropped image doesn't print as well as you would like. (See page 27 for information on how to avoid overwriting.)

Try an Extreme Angle

People are delighted by the unexpected—that's one of the concepts that all writers, photographers, artists, and other creative types use to their advantage. Visually, you can surprise people by showing them a subject from an angle they may never have thought of before. Have you ever laid on the ground and looked up at a dandelion? Have you (brave soul that you are) climbed a mast to look back down at the deck of a sailboat? You needn't get so extreme in finding unusual vantage points, but next time you're shooting a familiar subject (like your kids hanging out on the backyard swings) try finding a perspective that is totally unexpected. At the very least, you'll take people by surprise—maybe even yourself—and that's half the fun of taking creative pictures.

Exploit Design Elements

To the average person, a tropical landscape might be made up of a long curving beach, a rocky jetty, a few palm trees, and sailboat sailing into the sunset. But to photographers, that same scene is made of up lines (the beach), textures (the rocks), shapes (the trees and sailboat), and colors (the sunset). Learning to spot the visual elements hidden in common objects will greatly enhance your design sense and your ability to organize very complex scenes. Let's take a quick look at the five most basic design elements.

1 **Lines:** Like a twisting country road leading to a pretty covered bridge, lines lure us deeper into a scene and give us a roadmap for the ride. Our eyes have a natural curiosity towards lines that makes it almost impossible not to follow them to their destination.

2 **Shapes:** Like a circle drawn in the sand, when a line joins up with itself it becomes a shape, and shapes are one of the most primal ways we have of identifying objects. You don't need to see the face of a person silhouetted on the beach to know that it's a person—and if that shape is familiar enough, you might not even need a face to be able to recognize who that person is. No doubt, the mother of the family shown in the photo at right would be able to recognize her husband and son instantly if she saw this image.

3 Color Contrasts: The clashing of brilliant colors can be a very powerful design element, largely because colors stimulate the imagination. The key to capturing strong contrasts is to eliminate everything but the colors. In this shot of a hot air balloon, I zoomed in on the colorful stripes and excluded all extraneous subject matter.

4 Textures: Textures describe the surface of a subject. Virtually all objects—both large and small—have an inherent texture: gravel paths, burlap sacks, and the rough hewn surface of barn wood are all textures that we know. In fact, some textures are so real to our imaginations—like the smooth slippery surface of seaweed on rocks—that we know exactly how it will feel when we actually touch it (or what it will feel like when we slip off of it!).

5 Patterns: Whenever any of the design elements repeat themselves in some way, a pattern is born. To capture patterns, move in close and eliminate everything but the repetition. To highlight the pattern of these lobster floats, I simply stepped close enough to them to eliminate everything but the pattern.

Beyond 10
the Camera

Viewing, Sharing, and Printing Your Pictures

Unlike the days when processing your own pictures meant converting your laundry room into a makeshift darkroom, the real beauty of digital photography is that all you need to view, edit, or share your images is a personal computer. You can also print and enlarge your own images using a desktop printer, upload your pictures to an online lab or order prints, or take your memory cards to your local photo store and let them print your photos for you. Working with digital images is fast, clean, fun, and best of all, you don't have to spend your weekends hanging out in your laundry room (unless you're doing laundry, of course).

Transferring Your Images

Most digital cameras come with cables and easy-to-use software that enable you to attach your camera to your computer for quick and easy downloading of images. Once the software is installed, your computer will "recognize" your camera and automatically open an image-organization program for filing and storing your photos. If you're using a *Kodak EasyShare* dock, you can download your images by simply placing your camera in the dock and pressing the Transfer button. Other than their simple one-touch image transfer capability, other advantages to using *Kodak EasyShare* docks include that they remain permanently attached to your computer and they act as a battery charger for your camera.

Card Readers

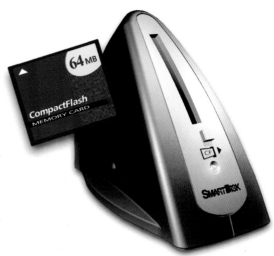

Another simple and inexpensive alternative for transferring photos to your computer is a device called a card reader. A card reader is a small accessory that stays permanently attached to your computer (via USB or FireWire port) and allows you to download images simply by inserting your memory card into the reader. Your images are transferred directly into the computer without having to use your camera.

© SmartDisk Corporation

Organizing Your Images

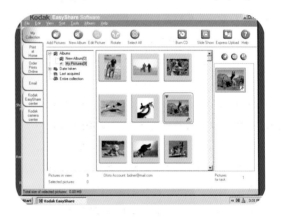

Once you get into the swing of shooting digitally, you're going to be surprised by how fast all of those digital photos add up. Even shooting just ten photos a week turns into 500+ photos in a year's time! Keeping track of your pictures and being able to find them when you want them requires some good organizational skills and regular computer housekeeping on your part.

Fortunately, there are a number of terrific and simple-to-use organizational software products on the market (many of which are free) that will help you caption, label, and file your digital photos in a methodical and organized way. *Kodak EasyShare* software, for example, lets you browse your photos by date, keywords, or using a "favorites" system that lets you rate your best photos. It also helps you create digital photo albums.

© Jenni Bidner

Kodak EasyShare software quickly sorts your pictures into albums, and shows you small "thumbnail" versions, as in the top photo. Double click your mouse on the thumbnail version you'd like to view, and a larger version of your picture will appear, as in the bottom photo.

If you decide to try to keep everything organized by yourself, without the help of software, be sure that you are methodical about filing and captioning your photos. I add about 10,000 new photos to my collection each year and the idea of having to scroll through that many photos to find one particular image gives me chills! Unless you devise and write down the concept you have in mind, your photo collection may quickly turn into a treasure map to the Lost Dutchman Mine.

Just how successful your digital photo organization will be depends on how methodical you are about sticking to your particular organizational system. Truly, the key to staying organized is taking advantage of the software that you have installed, and then sticking by your plan. Many times, the software that came with your camera will have organizational capabilities, and all you have to do is tap into them! Features like keyword searching and caption searching make finding any image very simple. By giving each photo that you download a few succinct keywords like "Hawaii, Sunset, 2006," for example, even if you forget where the photo is, you'll be able to find it by doing a keyword search.

You can choose keywords for your photos based on any number of useful themes: date, location, subject, etc. Be sure that you use keywords you'll remember many months (or years) down the line. If you happen to title a photo of your daughter and her boyfriend "Kate's boyfriend" and Kate has a couple of popular years, you might be looking at a lot of nervous young men staring into the lens when you do a "boyfriend" search. So be specific: "Kate, Joey, Prom, 2006."

In many programs when you download a batch of new images, they are entered into a "library" that contains all of the digital images you've downloaded. At the time of download, you can create a subfolder for a particular group of photos. For example, suppose you download 100 photos from your trip to Connecticut's Mystic Seaport. Just create a folder named "Mystic Seaport, June 2006" and those photos will appear both in the main library and in a list of alphabetical folders. As long as you can remember the name of the place, or the year or month that you were there, you'll find the pictures instantly.

The most important thing to remember with any organizational system is to follow good intentions with great follow-through. Take the time to create folders and to designate keywords to individual photos (or groups of photos) at the time of download because you will never go back and do it later. This way when Kate finally gets married, you will easily be able to go back and delete all those photos of the has-been suitors.

Emailing Your Pictures

The ability to email your photos instantly to family and friends around the world is extraordinary. In just seconds, your pen pals on another continent can be enjoying the photos you just shot. Because digital photo files can be very large, however, it's important that you follow some simple steps in order to prepare your images for fast and easy emailing. If you send friends huge files that take forever to download, they're going to avoid opening your mail—so take the time to prepare the images correctly.

Here are some simple steps for emailing your images:

1 Open the image that you want to send in your image-processing software program.

2 Select the Image Size or Image Resize option from your toolbar.

3 Rename the image and then save it with its new name so that you don't overwrite the original. (See page 27 for details.)

4 Set the image resolution to 72 ppi, which is fine for virtually all monitors.

5 Set the image dimensions to 4 x 6 inches (A6) or 5 x 7 inches (A5), then click Save.

6 Open your email program and use the Attach File button or command to attach the file to your email. Some programs will display the image in the message area, others require the recipient to download and save the image file.

Printing with an Inkjet Printer

There is no greater thrill in digital photography than seeing a big beautiful 8 x 10-inch print (A4) come rolling out of your printer in just minutes. The first time I made a color print on my home computer (of a rose in my garden) I was so excited I nearly ran down the street singing—it was that exciting! Home inkjet printing is not a difficult skill to master—it just takes some practice and a bit of patience. Almost any decent-quality inkjet printer will make acceptable prints, but if you're buying a printer specifically for printing digital images, look for one that says "photo quality" in the description. To learn more about all aspects of digital printing, check out The Kodak Most Basic Book of Digital Printing, by Jenni Bidner.

Make Prints without a Computer

If you have a *Kodak EasyShare* digital camera and a *Kodak EasyShare* printer dock, you can make great quality 4 x 6-inch prints (A6) instantly by simply attaching your camera to the dock and pressing a button. The camera and the dock communicate directly and you'll have your prints in minutes. Plus, *Kodak EasyShare* printer docks are small enough to carry with you, so you can make prints on vacation, at a friend's house, or even at work or school.

Using a Photo Lab

Don't worry if you don't have a personal computer or printer—you can still enjoy the fun of digital photography! Simply pop the memory card out of your camera and leave it at the lab just as you would with film. Labs can make prints, burn your pictures to CD, or even set up an online gallery of your photos so you can share them with friends around the world.

Kodak Picture Maker

Computer-phobics, take heart! Self-service workstations like the *Kodak* Picture Maker kiosks available at many camera shops and labs make it easy to personally enhance your digital images. Just insert your memory card, then follow simple on-screen directions to crop, rotate, adjust brightness and contrast, or color correct your images in seconds. You can even eliminate red-eye at the touch of a button. Once your pictures look their best, you can add borders or text and then order prints, enlargements, or even create special gifts like greeting cards or calendars.

You don't even need to own a digital camera to use these kiosks. You can download pictures from CDs, computer disks, or even cell phones. And if you have old family photos you'd like to bring into the digital realm, you can scan and adjust them to share with a whole new generation.

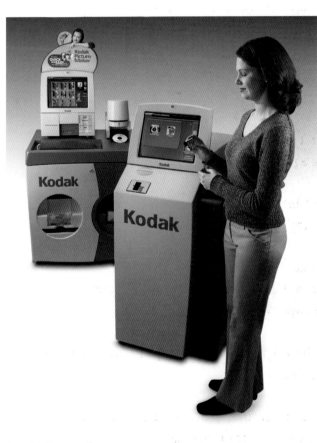

© Kodak Eastman Company

Online Photo Services

Another alternative to making prints yourself is to use the services of an online digital lab. Internet-based labs like *Kodak EasyShare* Gallery can transform your digital files into beautiful prints and enlargements, then return them to you in just a few days. All you do is upload your digital files from your computer to their site and tell them the size and number of prints that you want. Online labs are great for printing large numbers of prints, or for making extra large prints that are too big for your desktop printer.

Online Photo Galleries

Many online digital photo labs also offer free online gallery space so that you can share your photos with friends and relatives around the world. Galleries are often password protected so that only the people you invite can view them. One of the great things about online labs is that your family and friends can view the pictures at home and then choose the photos they like and order prints directly. Imagine attending a family reunion and then posting your photos to an online gallery—family members from near and far can order just the pictures they want and in any quantity and size they want. It's a really great way to share pictures and save money.

Archiving Your Images

Your pictures represent a large investment in both time and energy and, more importantly, they capture some of the fondest moments of your life, so it's a good idea to store them in more than one place. As reliable as computer hard drives are, they do fail occasionally, and it would be tragic to lose all of your hard work.

The simplest method for archiving your important images is to burn them to a CD. CDs are an inexpensive and reliable method for storing significant numbers of photos. Some computers also have the ability to burn DVDs, which can store a significantly higher number of photographs than CDs can. If you're not familiar with how to burn a CD (if your computer has that capability), read your computer manual to see what you need to do. The procedure is very simple. It only takes a few minutes, and it can spare you a great deal of agony if your hard drive crashes and takes your images with it.

Compact Storage Media

One of the realities of digital imaging is that (compared to word processing files or email files, for example) digital image files take up an enormous amount of memory space. Even if you're selective about which images you keep and are good at computer housekeeping, eventually you'll clog your entire hard drive if you don't move some of the images off of the computer. Even if you don't shoot that many digital photos, it's a good idea to back them up onto a media that exists outside of your computer. That way if your computer crashes, you won't lose all your photos.

The simplest and most compact method of image storage is to burn your files to CD or DVD. There are several choices available, and the media you choose will depend largely on how many images you need to duplicate and whether you need to store them long term or just temporarily until you move them to a new location (like an external hard drive, for example). Here are the basic compact storage media categories:

CD-R: Use these CDs for single-session backup and storage (one-time recording only). Each of these discs will hold a moderate number of images (depending on image file sizes) and they are easy and fast to burn. Most CD-R discs sold today store up to 700 MB (megabytes) of data. Simply look at your images and see what your average file size is, then divide 700 by that number to see how many photos will fit on one disc.

CD-RW: The RW stands for re-writeable. This means that these discs can be erased and reused. These are not the discs that you want to use for storage. You could accidentally erase over the images you're trying to preserve! The only reason you might want to use a CD-RW disc would be if you're transferring images from your computer to another location, like a friend's computer or an external hard drive. Just remember that in order to add new photos to a CD-RW disc, you've got to erase everything that is already on the disc (unless it's brand new, of course). In other words, you can't burn a few pictures to a CD-RW, then decide to add a few more the next day. You would have to find and re-burn everything that was already on the disc in addition to the new material.

DVD: DVD discs hold an amazing quantity of photos—4.7 GB (gigabytes), which typically means hundreds of high-resolution files. However, this is only an option for you if your computer has a disc drive capable of not only reading but also writing DVD media. Also bear in mind that DVDs are substantially more expensive than normal CD-R media (though prices continue to fall).

Image Processing

Sky not blue enough? Mountains not sharp enough? Litter ruining your pristine beach scene? Fear no more. Basic image-processing programs can solve these and thousands of other technical and creative dilemmas. There are also good software programs that sell for less than $100 and offer many of the same capabilities as professional programs costing several times as much.

Indeed, if there is one thing above all else that sets digital imaging apart from film photography it's the ability to easily correct and enhance your photographs. While it does take practice and a certain amount of devotion like any other hobby, you'll be surprised how fast you learn the tricks of image processing once you apply yourself on a regular basis. And some software fixes, like correcting red-eye in portraits, take literally just a keystroke or two—anyone can learn to do it.

Creative Image Manipulation

For many digital photographers, creativity begins where the camera leaves off, and the real fun begins in the computer. The same image-processing tools that are used to correct flaws and enhance reality can be exploited to create strange and fanciful visions. If things like butterflies with melting wings and pink cows standing in Times Square turn you on, you're going to love the potential of creative image manipulation. Like a super-charged jolt of imagination in a bottle, image-processing software programs let you twist, pull, stretch, churn, and obliterate the familiar into strange and new dimensions. It's a place where fantasy is more important than fact and imagination is more important than reality.

Learning to distort reality is largely a process of experimenting and exploring uncharged visual paths. Just remember that there are no mistakes when it comes to creative image manipulation—every experiment is just a jumping off point to a new creative reality.

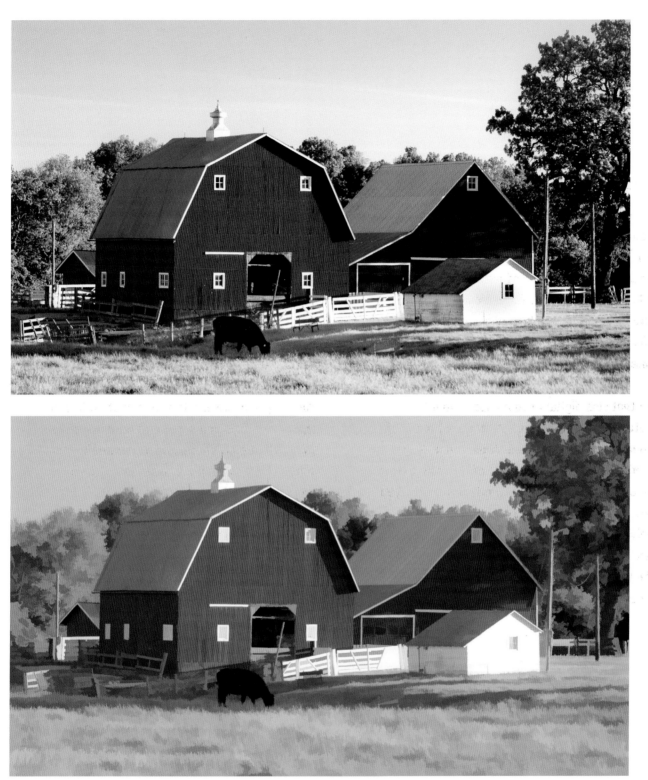

The manipulated version of this barn photo was created with an Adobe Photoshop plug-in filter called buZZ.X, from Fo2PiX Limited (www.Fo2PiX.com).

Index

light meter 37, 45, 48, 65
lighting
 artificial light 60
 available light 65
 backlight 62, 63
 bounce flash 71-72
 built-in flash 16, 59, 65, 69, 70, 71
existing (ambient) 65, 66, 69, 70
 fill flash 69, 71
 front light 60
 side light 62
lossy 28

M
macro photography 35
magnification factor 32
Manual Exposure Mode 46
megapixels 19, 20
memory card 9, 10, 21, 22, 26, 27, 28, 85, 86, 89
metering 17, 37, 45, 46, 48, 65
monopod 54
monitor
 computer 20
 LCD (see LCD monitor)

N
nighttime photography 38, 47, 60, 65, 66
noise 43

O
online galleries 13, 89, 90
optical zoom 16, 17, 34
organizing image files 13, 86-87

P
pixels 16, 19, 20, 78
ppi (pixcls-per-inch) 20, 88
pre-focusing 59
printing 19, 20, 85, 88, 90
Program Mode 45

R
RAW 27
red-eye (reduction) 11, 69, 70, 72, 89, 92
resolution 19, 20, 22, 78, 88, 91
 camera 19, 20
 image 20, 88
 print 20

S
sensor 16, 18, 19, 32, 33, 37, 40, 43, 64, 66
 CCD (see CCD)
 CMOS (see CMOS)
Shutter Priority Mode 46
shutter speed 38, 41, 42, 45, 46, 47, 53, 54, 55, 65, 70

T
telephoto lens (see lens, telephoto)
TIFF 27, 28
tripod 34, 47, 53, 54, 65, 66
TTL (through-the-lens) 17, 72

V
viewfinder 10, 16, 17, 18, 25, 31, 52, 57, 59, 70

W
white balance 53, 65, 66
wide-angle lens (see lens, wide-angle)

Z
zoom lens (see lens, zoom)